P9-CTA-891

The WRINKLIES'™
GUIDE TO

New pursuits for old hands

Richard Pomfret

PRION

First published in Great Britain in 2012

Prion Books
an imprint of the
Carlton Publishing Group
20 Mortimer Street
London W1T 3JW

Illustrations: Peter Liddiard
Text: Guy Croton

A catalogue record of this book is available from the British Library.

ISBN: 978 1 85375 839 3

Printed in the UK by CPI Group (UK) Ltd, Croydon, CR0 4YY

10 9 8 7 6 5 4 3 2 1

CONTENTS

FOREWORD

I truly believe we never stop learning. Our capacity to develop a new skill and turn it into a passion is one of life's real joys and since hitting "a certain age" my motto has been "It's NEVER too late".

In my 40's I learnt all about TV and combining this with my drawing, I developed a successful career in TV with my show *Art Attack*. Approaching 50, I decided to grow old (dis)gracefully and re-formed my teenage rock band and now that I am over that hill (and still enjoying it very much, thank you), I have recently released my first full fine art collection of paintings. So, as I said – it's never too late!

Actually, I LOVE being this age! I have never been so creative in my life and now having a bit of time on my hands and a true appreciation of the good things in life, I am really enjoying my creative adventures. And that is exactly what any form of creative learning is – a joyous adventure.

So go on – pick up that pencil, crayon or whatever you like that makes a mark and DO IT! It feels real good! And I promise you – you will be hooked. Oh, and the good news is – there are no rules. It's all about you and your own self-expression. If you can hold a pencil – then you can draw. You may need a few tips and guidelines to get you started,

but that is where this book comes in. The author has compiled a really inspirational collection of pointers to get you started, help you along the way and then set you off on your own creative journey. Enjoy this guide, learn from it and then develop your own style and you will get so much enjoyment from this exhilarating hobby.

For 17 years on TV, I have been teaching young people to draw and have been taking them through the "I can't do that" barrier. Trust me, the most important step is the first one and the most important thing is to ENJOY it. *The Wrinklies' Guide to Drawing* will place you on the first inspirational rung of the creative ladder and will then help you climb as high as you want to go. I hope you enjoy every step your creativity takes. I have!

"Drawing from Memory Lane" – which covers everything from sketching old photographs to converting distant memories into self-drawn souvenirs is something I would wholeheartedly endorse. A little while ago I began painting my own childhood memories, based on my childhood days growing up in the great outdoors in the early 1960s. It was a thoroughly liberating experience and one which resulted in the publication of my first collection of limited edition prints. These are entitled Neil Buchanan's HOPE STREET they are "the story of childhood" and the only thing I packed for the ride was my imagination.

Neil Buchanan
Creator of BAFTA award-winning *Art Attack*
and fine artist behind Neil Buchanan's
HOPE STREET "A story of childhood"
www.neilbuchanan.co.uk

INTRODUCTION

Drawing ... What exactly does that mean to you?
Maybe these days it makes you think of drawing breath
– just a thought! – or possibly drawing cheques for the
inexhaustible supply of bills you are obliged to pay?
Perhaps it's drawing cash out for your children or
grandchildren – we bet you do a lot of that! Drawing
curtains, drawing a bath – we could labour the point, but
clearly this time it's the real thing – the delightful hobby
of creating illustrations. If you are looking for a new
pastime to fill your days, you have come to the right place
– and you won't find one more rewarding than good old-
fashioned drawing.

Drawing has evoked a lot of comment over the years from
some very famous people. Try this selection of quotations
about this absorbing hobby:

> *Art, like morality, consists in drawing the line*
> *somewhere.*
>
> G. K. Chesterton (poet and novelist)

> *I prefer drawing to talking. Drawing is faster, and*
> *leaves less room for lies.*
>
> Le Corbusier (artist and architect)

Drawing is the honesty of the art. There is no possibility of cheating. It is either good or bad.
Salvador Dali

For the purposes of this little book, the Dali and Le Corbusier comments are particularly apt. This is because, of all the hobbies you could choose in the autumn of your years, this is the one that is invested with the most sincerity, the most inherently fine values, the most dignity – in short it is a worthy hobby to engage in! It's relatively inexpensive as well, which of course is always a bonus … Oh, and don't worry about what the extravagantly-moustached Mr Dali had to say about drawing being either good or bad – we are sure that, with the help of this little tome, yours will only be good!

Confidence is everything

Perhaps you are approaching this gentle foray into the world of art with more than a little trepidation. After all, as an artist – even a mature, amateurish one – you will be in some venerated company. But don't be petrified of Picasso, dismayed at Da Vinci or mithered by Matisse – with practice (a lot of practice!), and in time, you will seek to emulate these greats, not fear them. Because anyone can draw – it's all just a question of confidence.

You will gain the confidence you need to draw well by carefully following the advice in this book. We show you how to master the basic skills of this fantastic pastime and then give you invaluable tips on how to draw everything from landscapes to still life, with people and animals in between. There are even chapters on how to create

8

your own cartoons and caricatures and, in keeping with this time of your life, how to evoke and capture golden memories from your distant past.

There are no confusing diagrams and endless visual sequences in this book – just straightforward, common-sense, black-and-white line illustrations that we invite you to copy or that will show you the way without blinding you with science. This will enable you to conserve your mental energy and save your patience for your own creations. What could be better or simpler than that?

Drawing on experience

This is a great time in your life to be taking up drawing. As we say above, you will need lots of practice and that will take time – but hopefully you've got a fair bit of that on your hands these days. You will also need peace and quiet – drawing is a pretty solitary hobby – but then again, if you have got a big family, get them round and practise your portraiture on your favourite people! Oh, and your dog and/or cat will also become a useful subject too!

If you are worried about developing your skills alone, why not get your husband, wife or another close relative to take up a pencil beside you? Nothing could add more to the tranquil contemplation that comes with drawing than sharing and comparing burgeoning illustrations with the person you know and trust best of all. Finally, once you have read this book and developed your skills a little, why not consider joining a drawing class and taking your new

hobby on to the next stage? There are lots around – just check your local arts centre or newspaper or have a look on the Internet.

Right, buckle up and prepare to have the time of your life. Let's draw!

Chapter 1

YES, YOU CAN DO IT!

So, off we go! You've decided to have a stab at drawing – which is great, as it is a really terrific hobby – so now it is time to find out how. Many people think that learning to draw is difficult, if not impossible. However, it need not be like this at all. Drawing is really like anything else in life – if you believe that you can do it, the chances are that you will find a way to do it.

Think of learning to draw as like learning to drive. The first time you got behind the wheel of a car, the chances are that you were terrified – but doubtless you picked up the skills pretty quickly. Well, drawing is basically the same. Once you have discovered how to draw landscapes, animals, people, cartoons and all the other things covered in this book, you should have no problem at all managing with any subject.

As with anything new, taking the very first step is the most difficult. However, if you approach drawing with a positive attitude, believe that you can do it, be realistic, and expect to make mistakes at the outset, then you will soon get

the hang of it. Bring some of your experience and world weariness to bear – don't worry about what other people think and just carry on, no matter how awful you think your initial scribbles are. If you do this, your self-confidence will build in no time and you will begin enjoying this most wonderful of pasttimes. Happy drawing!

Finding the Artist in You

Perhaps you are coming to drawing for the first time, relatively late in life. However, alternatively you might be taking the hobby up again, having drawn in the past. Whichever of these statements applies to you, the first thing you need to do when beginning to draw is to find the artist in you.

This might sound terribly pretentious. Maybe you are far too old to think in such existential and arty terms! However, if you want to make the most of this hobby and develop your drawing skills to the best of your ability, you need to be able to reach inside yourself and find the creative 'you'. For although drawing is largely a technical skill, it also involves interpretation and individuality. Ultimately it is your personality, your thoughts and feelings, which will define the style of your drawings as much as the technical ability that you bring to bear.

But we don't want to get you too hung up on these abstract thoughts at this stage in proceedings! Instead, let's start with some hard and fast facts.

Expect mistakes

Don't expect to become Pablo Picasso overnight! On the contrary, as with any new skill, it is common sense to expect that you will make a lot of mistakes when you first begin drawing. It's just part of the learning process. But don't beat yourself up about all this – instead, persevere.

There are three basic tenets of learning to draw that you should always bear in mind as you start out:

• The requirement to look closely and properly at things as you draw them.
• The need for self-confidence as you draw.
• The capacity to remember and carry out basic instructions.

If you follow these basic rules, you will soon find that you master the fundamentals of draughtsmanship.

Believe in your ability

Do you have any preconceived notions about drawing? Read each of the following three statements and decide if they are true or false:

• In order to take up drawing, you already need to be able to draw fairly well.
• If you don't have any innate or natural talent for drawing, there's no point in wasting your time trying.
• Drawing is an elusive and magical art that is accessible only to certain gifted individuals.

If you answered 'true' to any of the statements, you'd better start reading from the beginning of this book all over again! The plain and simple fact is that anyone can draw. Don't be intimidated by the friend, cousin or aunt, whom you've always believed to be 'really good at drawing'. Your perception of their ability is relative, and there is absolutely no reason why you should not develop skills yourself and become a competent artist in your own right. You can draw – tell yourself that, and you will draw! And if you're someone who simply does not like making mistakes, the good news is that there is no 'right' or 'wrong' way to draw, but rather only the need to overcome your own insecurities and accept your own unique individuality.

If you're still not convinced, think about the following point – can you write? The 26 letters of the English alphabet are some of the most difficult and complex shapes you will ever encounter with a pen or pencil. However, there are no shapes in nature that are anything like as intricate and contrived to form. Yet every day you craft and scribble these extraordinary symbols … Well, doubting wrinkly, if you can use a pen or pencil with that level of proficiency, why should you not be able to draw anything that you see before you?

So, think positive, believe in yourself, grab some drawing supplies and dive in! We are sure you won't regret it …

Finding Space and Time to Draw

If you enjoy the luxury of being retired, or semi-retired, then hopefully you will have plenty of free time to begin drawing. We would have a bet with you, though, that your

life is still really busy, regardless of whether or not you have stopped working! There are always 1,001 things that can get in the way of your hobby and which you might regard as more important and therefore taking precedence. The dog needs walking, your other half needs feeding, the grandchildren need shepherding, and the armchair definitely needs sitting in ...! You get the picture.

For these reasons, it is important to set time and space aside for drawing. You will only improve in your art if you practise regularly, and you will only really find the pleasure and satisfaction that drawing can bring by getting better at it.

So, try to set a regular time aside several times a week – or ideally every day – when you will draw. It need only be an hour or so, and you would be amazed how much you can achieve in such a short space of time. Make this your time – dedicated time for the pursuit of your new hobby – and make it clear to your spouse, family and friends that you will not be available to them when you are drawing. That might sound harsh, but drawing is largely a solitary and highly contemplative pursuit, particularly when you're starting out and trying to get the hang of it. You simply will not improve if someone is talking to you nineteen to the dozen or peering over your shoulder and offering an opinion every time you set pencil to paper.

That special place ...

By the same token, you need somewhere to draw. If it is autumn or winter when you start – the nights are drawing in and it's getting cold – it is probably best to preserve your wrinkly skin and bones by staying indoors to draw.

In this case, make the spare bedroom or study your studio – somewhere quiet and peaceful, where you can be alone and concentrate on honing your skills. Kick out the cat, turn off the telephone and settle down with a pad and pencil. We'll discuss what you might try to draw a little later in this chapter, but for the time being concentrate on finding the space that you need.

If you have a nice garden with somewhere to sit – or a decent park bench nearby – and the weather is sufficiently hospitable, you might prefer to go and draw outside. The second you step outside your front door you will be presented with a multitude of subjects to choose from, which is the best thing about sketching in the great outdoors. Of course, this way it is also easier to get away from the clamouring hordes with whom you might be fortunate enough to share your life! Or at least the cat … Anyway, take up your pad and pencils and off you go. Bear in mind though, that ideally you will need a comfortable place to sit as you sketch or an easel to stand your pad upon. Also, be mindful of the intrinsic disadvantages of drawing outside – the breeze that blows your sketch pad away, the random raindrops that smear your beautiful lines, the dust and leaves that blow in your face at a crucial moment in your composition, or even an errant pigeon with a tummy problem flying overhead …!

Choosing Subjects for Drawing

One of the best things about drawing is that you can choose anything you like as a subject. You can literally draw anything – from real life, from a picture in a book

or magazine, from your own imagination, even from your computer screen. The choice is yours. In its sheer lack of limitations, drawing is pretty much unique as a hobby.

The other great thing about drawing is that when you first start you will soon discover that the basic techniques you use apply over and over again, no matter what your subject might be. While obviously there are huge differences between animals and people and between rural and urban scenes, the same principles of drawing hold good across a multitude of subjects, as you try to render them in as lifelike a manner as possible. For this simple reason, there is nothing to prevent you from attempting any particular subject right from the outset.

Landscapes

Many novice artists start out by drawing landscapes and countryside scenes. This might be because we all feel drawn to the themes of nature, but also it might be because from a technical point of view it is easier to render the abstract forms of distant trees, water, skies and hills on a broader, less detailed canvas. Realistic drawings of the features of landscapes draw the viewer into the scene and evoke feelings of tranquility or excitement according to season and setting. Changes in the weather and natural light present interesting challenges for the artist, in which case photographs can be very useful as reference points for 'tweaking' the drawing back in the studio later on. Perhaps the greatest thing about landscapes is that they are always changing. For centuries many great artists have painted or drawn the same landscape repeatedly in an attempt to reflect its ever-changing diversity.

17

Animals

Wildlife has been a popular subject for drawing ever since cavemen finger-painted and scratched out remarkably sophisticated images of animals in their subterranean, prehistoric homes. The fascination with creatures of all kinds as subjects for drawing has not diminished to this day. Perhaps it is the diversity of the animal kingdom that is the reason for their ubiquitous popularity among artists, or the fact that their innumerable poses and positions offer the artist so many opportunities to capture action and movement in their drawings. Whether it is a dog sitting on a hearth rug, a bird pecking on a seed table or a distant stag viewed through a pair of binoculars, animals offer artists unparalleled variety.

Buildings

The lines and geometric forms of buildings throw up new and different challenges for the amateur artist. Whether the building in question is a church or a skyscraper, getting the perspective and proportions right is vital to producing a drawing that will convince the viewer of the structure's reality. Once those basic elements have been mastered – so that the form of a building looks as it should, rather than like a squashed sandwich box – adding texture, light and shade will give a building real form and solidity. The other challenge with drawing buildings is just how much detail to include – sometimes it's what you leave out rather than what you put in that can really 'make' a drawing ...

People

When they are starting out, many students of drawing
choose to sketch friends and family as early subjects.
This might be because they are easily on hand and
can possibly be trusted not to be highly critical of the
outcome! Then again, perhaps it is the sheer range
of human expression – particularly facial expression
– that makes people such a popular choice of subject.
Portraying facial characteristics and expressions
accurately is probably the hardest aspect of drawing to
master. Certainly the greatest technical skill and accuracy
is required in order to capture accurately the slightest
alteration of mouth or eyelid, and it is probably in
drawing human beings that the artist's own sensibilities
and individual emotions are most called upon.

Still life

Do you remember art class at school, all those years
ago? You probably spent hours slavishly trying to render
the bowls of fruit, vases, teacups or decanters that your
teacher put before you. That is because these are the
traditional mainstays of 'still life', an art form in its own
right to which countless individual books have been
devoted. As the name suggests, the beauty of these subjects
is that they don't move! This makes them easier for the
greenhorn draughtsman to draw. The other advantage of
still life drawings, of course, is that you can make them in
the comfort of your own home, without having to seek out
any particular items or spend time and money preparing
for some special subject.

There is lots of detailed information about drawing all these subjects and many more later on in this book. However, as we said earlier, the choice about what to draw is entirely your own. The main thing is to enjoy your drawing and to take pleasure in observing the things that you attempt to replicate.

Selecting and Buying Equipment

The fun all starts when you first head off to the art shop to buy the paper, pads, pencils and pens that you will need to begin practising your new hobby. Fun, because these days there is such a hugely exciting array of materials to choose from! Things have moved on a lot from your time in the art room at school, and as with everything else in modern life there is a mind-boggling abundance of different items you can buy. Of course, none of these will turn you into Rembrandt overnight, but once you have laid out your cash or bent your credit card a little bit, you can certainly enjoy trying.

Before you leave for the art shop, you should give some thought to the kind of drawings that you wish to create. Each drawing tool creates its own distinct feeling and effect, and you will need to choose the one most appropriate for the particular drawing you wish to do. Shop assistants in specialist art stores in particular tend to be very knowledgeable, so don't hesitate to ask for advice if you are in any doubt at all.

Pencils

The humble pencil is the absolute staple of any form of
drawing. An incredibly versatile instrument, the pencil is
capable of producing both rough, quick sketches and finely
worked detail. There are many different kinds of pencil.
Of the ones that you are most likely to start off by using,
the graphite or 'lead' pencil ranges from the super-hard 9H
to the luxurious and softest 9B, with the HB in the middle.
The H range provides you with a light, hard, precise line
which is ideal for detailed studies of shape and texture.
The soft B range can provide rich, rough, textural effects
and striking tonal variations. With the latter, it is easy to
smudge the graphite trail on the paper to create all kinds
of effects suggesting depth, light and a sense of action and
movement.

One of the disadvantages of pencils is that they constantly
need sharpening. However, you can overcome this problem
by trying clutch and propelling pencils. These are more
expensive and come in a smaller range of hardness and
softness, but they offer a continuous and consistent line
and can be particularly useful if for any reason your
drawing needs to be accomplished quickly.

Coloured pencils are obviously a good option if you wish
to draw and introduce colour simultaneously. You can also
buy watercolour pencils, which produce a line that can be
softened with a wash of water.

Buy a range of pencils when you are starting out and
experiment freely with them until you find out what works

best for you. If you're not happy with the results, you can always use an eraser to rub them out!

Pens

If you are fairly confident in your ability and don't intend to spend a lot of time rubbing drawings out, you might prefer to start out with pens. These will produce fluid, uncompromising lines and a variety of effects that cannot be achieved with pencils. There are several different types:

- Ballpoint and technical pens produce a consistent, fine line. Ballpoints are widely available, quick and easy to apply and useful for sketching moving subjects.
- Fountain and dip pens enable you to apply lines of varying thickness, depending on the pressure applied. They are good for drawing both free-flowing and angular lines.
- Felt-tip pens come with nibs of a variety of different widths. They can create a range of effects.

Pastels, crayons and chalks

It's best to start out by mastering drawing using pencils and pens, then once you become more confident you can explore the incredibly varied textures and tones that pastels and chalks offer as an alternative. These media work best on rough textured papers and can produce more abstract effects than the largely precision lines that are produced by pens and pencils. Smudging is the order of the day when using crayons and chalks, whose rich, powdery marks and lines can be easily blended together on the paper.

You will find all kinds of colours available with these items, and no end to the range of effects that you can achieve with them. One of the great advantages of pastels and chalks is that they can be used on their sides to fill large areas of a drawing very quickly. You could also try oil pastels and wax crayons as a further alternatives. Finally, compressed charcoal and graphite sticks offer additional effects along the lines of particularly generous pencil strokes. Once again, these items can be used to fill up the paper very quickly.

Care should be taken with all these soft, crumbly media not to smear them inadvertently with your hand as you are drawing. Otherwise, what started out as a colourful and interesting-looking effect could quickly end up looking like the top of a ham and pineapple pizza after it has been in the oven!

Of course, there are many 'wet' media that you could also consider, but in this book we are going to stick with drawing and not diversify into the soggier form of art that is commonly known as 'painting'!

Paper

There are lots of different kinds of paper to choose from, and this is where you might really benefit from some specialist assistance. If you can find somebody knowledgeable to help you, it is a good idea to explain the kind of drawing you are intending to do and which medium you propose using. Then, rather than wasting lots of money on often expensive papers that might prove totally unsuitable, you can get off and running with

something that will work well with your pencil, pen or crayon of choice.

Cartridge paper – in either cream or white – is probably your best bet when you're starting out. It is the most versatile surface for day-to-day drawing and can be bought in either rolls or sheets. There are cheaper papers available and these might meet your needs in the early days. If that's the case, just pick up a ream of photocopy paper from your local supermarket. Alternatively, you could try some brown wrapping paper, which is a good tough surface to work on, enabling some interesting effects to be created.

It is probably a good idea to buy some tracing paper as well, as this is semi-transparent and can be used to lay over other images for tracing.

Pastoral and Ingres papers, available in many colours with textured surfaces, are ideal for pastel, charcoal and conté work.

Finally, two other options that are probably worth considering are layout paper and Bristol board. The former is a semi-opaque, lightweight paper which is suitable for both pen and pencil and the latter as a smooth surface which is good for drawings in both pen and ink.

Watercolour paper is the most expensive paper for drawing. However, unless you're planning on doing a lot of vigorous drawing accompanied by watercolour washes, you probably will not need this medium until you become more ambitious.

Other Practical Considerations

If you want to 'get away from it all' and do lots of
your drawing outdoors, you will need some specialist
equipment in addition to your papers, pencils and pens.
It might be worth acquiring an easel, so you can stand
in front of your paper as you draw, or at the very least a
block, book or pad.

Blocks consist of ready cut and stretched watercolour
paper on a card base. Books consist of watercolour or
cartridge paper bound with a hard back. Pads are usually
made of cartridge paper, spiral bound or glued. They
are available in either 'portrait' (upright) or 'landscape'
(horizontal) format. Choose the shape that most suits the
subjects you intend to draw.

The paper used in books and pads generally comes in one
of three grades of surface, varying from smooth to rough.
Again, ask your art shop assistant which is best for the
media you plan to use. As a general rule of thumb, smooth
surfaces are best for pen and wash and detailed pencil
work. Rougher surfaces suit bold, dark pencil, charcoal
and crayon. Pastels and chalks do not take to smooth
surfaces because their particles cannot cling to them; they
are best suited to tinted pastel paper.

If the great outdoors is for you, then it goes without saying
that you will also need a good warm coat with a hood,
and a waterproof bag in which to keep your drawing
tools and materials. The latter should ideally have a stiff
back so that your compositions do not become creased as

you travel to and from your home. Of course, you could always simply get your spouse to come along and act as pack horse for you ... He or she might also look good featured in one of your landscapes!

Chapter 2

LEARNING THE BASIC SKILLS

Although drawing, like all other forms of art, is primarily about individual interpretation and style, there is definitely a right and wrong way to do it. Like anything else in life, drawing has its own rules. These might not be as certain as death and taxes, to paraphrase the old maxim about life in general, but they are very important if you want to draw successfully and they have evolved over many centuries and in many different cultures.

It is these fundamental rules of drawing that basically define the skills you need in order to draw well. Now, you might be a bit of an old maverick and have reached a stage in your life where you are simply not interested in rules any more and when you just want to do your own thing. Do you remember that famous poem about the old woman who insisted on wearing only purple, with a red hat that 'didn't go', as a sort of personal protest against the rest

of the world? A dramatic sartorial 'two-fingered salute', railing against the world as the light began to dim ... Well, if that is you, then perhaps you should swiftly bypass this chapter and carry on drawing in your own unique, rule-free way! However, if you wish to learn how to improve your drawing and master some key fundamental techniques along the way, read on.

Yes, this is the boring, technical part of this book. However, we make no apologies for the information we provide here, which will make your enjoyment of the more 'fun' chapters to be found later on all the greater.

Seeing as an Artist

Think about your eyes for a minute. If you are lucky, they will have served you well for quite a few decades now. But maybe they're not quite as good as they used to be – at the very least, most people find they need more light to see detail clearly as they get older, that is if they are lucky enough not to actually need glasses. Even if the quality of your vision has declined, you have probably always looked at things in the same way. Well, now that you've taken up drawing, you need to start looking at the world and everything in it from an artist's perspective.

This is not as daunting as it might sound and can, in fact, be a lot of fun. The world is a totally different place when you see it through the eyes of an artist. From this perspective, everyday objects that you have seen thousands of times before suddenly look different, positively teeming with new lines, angles, textures, proportions, nuances

and even importance. Suddenly absolutely everything is a potential subject for drawing, which is what makes seeing in this way so enjoyable.

This is a different way of seeing which is defined not so much by your eyes but rather by your brain. To be more specific, the two distinct halves of your brain, both of which play an equally important part in the success of your drawing exploits.

Understanding and harnessing brainpower

Now, in the immortal words of *Dad's Army's* Corporal Jones, 'Don't panic!' You might think your brain is very old and withered, but actually in many ways it is probably just as sharp and acute as it always was. For the brain is a quite remarkable thing that we know very little about. It is commonly believed by scientists that we use only 10–20 per cent of our brain's power. That means you have still got plenty in reserve, even if you are in the autumn of your life!

When you begin drawing, elements of your brain begin working differently to enable the new and different vision that you require. Of course, it's not necessary to know exactly how your brain functions in order to be able to draw well: no one is expecting you to become a neurosurgeon as well as a novice artist! However, for the purposes of this book, it is worth briefly exploring what the two halves of the brain actually do and how they affect the way you see things as you draw them.

It is the right-hand side of your brain that does all the visual and creative thinking. It is responsible for:

- Seeing the relationships and likenesses between shapes and spaces.
- Combining the various visual elements that form an entire image.
- Instinctively seeing composition.

Conversely, the left-hand side of the brain does all the mathematical and calculator-like stuff. It:

- Uses mathematical logic to establish proportion.
- Helps you in your planning of a composition and applies the rules of composition.
- Analyses the step-by-step procedures involved in composing a drawing.
- Names the parts of the object you are drawing.

The two sides of the brain work in concert to enable you to draw. The one without the other is useless, which is why people with damaged brains often lose their ability to draw completely.

Exploring for drawing

When you begin seeing the world through the eyes of an artist, suddenly everything has drawing potential. The choice of subjects is infinite. Look around you. Every piece of furniture, every ornament, your other half, your pets – these are all potential subjects for drawing, as well as the pattern on your wallpaper. If you break down these elements further and look at only parts of them, or details, you can see even greater potential. After all, a drawing need not always be of the complete item – it can be of just part of it.

Get into the habit of analyzing the shapes, lines and textures of everything that you look at. Focus on the interesting details that you can find in familiar everyday objects. Just about anything can be worthy of drawing with your pencil.

You will find that exploring for drawing is more fun if you concentrate on things that really interest you. If you are serious about making drawing a regular pastime, you are more likely to succeed in keeping your hobby going by drawing subjects that really appeal to you. See if you can find some interesting old antiques in your attic or go out into the garden and look really closely at a favourite tree or shrub. Doing this is not only a great way to find subjects for sketches, it might also remind you of where you have left a few things!

As we will say many times in this book, here and elsewhere, observation is the key to successful drawing. It is only by learning to look really closely at your subjects that you will capture their true essence on the paper in front of you.

Your mind's eye
Look at the clock on the wall, if you have one. If not, pick any other item close to you as you read this. Take a long, hard look at the object you have selected. Now, close your eyes and try to see the object in your mind. Can you see it? Is it vivid in your head? Is it really just like looking at the real thing, only with your eyes closed? Now, open your eyes again and look at the object once more. Grab a pen and piece of paper and immediately write down any discrepancies between what you see before you and what

you saw in your mind seconds earlier. There might not be any differences at all, but then again maybe your mind embellished the object you were looking at with a few extra features or dimensions? This is your 'mind's eye' at work – your ability to visualize within your imagination. Everybody's imagination is different and consequently the way that they see things in their minds varies as well. Although your eyes might have seen their fair share of weird, wonderful or possibly even horrific things during your long life, the chances are that your mind's eye will have imagined things far more fantastical, whether in dreams or in your waking consciousness.

If you are having trouble grasping this concept, think of the art of William Blake, Hieronymus Bosch or Salvador Dali. All these great artists drew heavily on their imaginations – their minds' eyes – to create powerful and incredibly vivid images ranging from the monstrous to the utterly surreal. If you're not familiar with the works of these men, give yourself a treat and look up some of their images on your home computer or next time you visit your local library.

Different visual perceptions

If you need any more evidence of how your brain can see things differently from your eyes – or how the two things work in concert to enable you to see things differently check out the work of the Dutch artist M.C. Escher, who specialized in optical illusions and mind-baffling visual devices. Lots of Escher's drawings and paintings are available for viewing online, if you have a home computer. If not, again libraries can help, both with books and Internet access.

Starting with Scribbles and Doodles

One of the hardest things to do when you start drawing is to really get started! Just as writers get 'writer's block' and sometimes cannot put pen to paper (or these days, more likely, fingertips to keyboard.), even with their chosen subject before them, the amateur artist finds it hard to get going. Well, if you find yourself sitting there with your pencil tip hovering above your pad or sheet of paper, try a few simple doodles to get yourself warmed up.

What are doodles?
Doodles are squiggly, inconsequential little sketches that can be of any thing that comes to mind. Very often they make no sense at all! Everybody's doodles are different. The key thing about them though, is that not only do they get your hand and pencil warmed up, they also warm up the creative right side of your brain, unlocking the powers of your imagination and creativity.

Try a few different shaped doodles. Draw a large square and a succession of smaller squares within it. Now try the same thing with a circle and a triangle. Take the same idea a little further and draw a couple of pentagons, hexagons or octagons. Now, forget geometric lines altogether and draw a succession of swirls and squiggles. Block in some of the shapes with solid shading. Add some further swirls and try to begin adding some identifiable form to your doodle. Can you feel yourself relaxing? Are your artistic juices beginning to flow? Hopefully, at the very least your brain will start to feel a bit more prepared and ready to draw!

A simple doodling exercise

Try this doodling exercise. As you draw, include lots of straight, angled and curved lines. Let the lines in the doodle cross over one another in lots of places and change the direction of the lines as much as you can. Follow these steps:

1 Pick a place on your page to begin doodling. Anywhere will do.
2 Make a small dot on the page with your pencil. This is where your doodle begins and also where it will end.
3 Begin to draw a doodle that covers the entire page.
4 To complete the doodle, head your last line back towards the dot that you started with. Finish by joining the two ends of the line together at the dot.

So, what do you think of your doodle? Can you see anything in it? Turn the page round in your hands and look at the doodle from each of the four sides of the paper. You might find this easier if you number the four sides with your pencil first, one to four. As you turn the paper in your hands, see if you can identify some different shapes – maybe faces or objects from nature – and colour them in as you find them. If this becomes confusing or the next time you look at something it appears different from how you first saw it, it might be a good idea to keep a numbered list of what you find and then add tiny corresponding numbers to each of the individual forms. Use a variety of coloured pencils to differentiate the different shapes and objects that you identify.

Don't worry if you can't really find anything interesting in your doodle – sometimes it just works out that way!

However, if you do come up with some identifiable shapes, you could then try converting them into drawings on other pieces of paper, by adding more lines and details. You probably won't create any fabulous works of art by working in this way, but exercises like this will certainly help you get in the mood for drawing and warm up your brain, hand and pencil!

The Basic Principles of Good Composition

Ask a group of professional artists what they think are the basic principles of good composition, and they will probably each give you a different answer. There are so many different strands to good drawing that it is difficult to sum up the essence of illustrative composition in only a few brief terms of reference. However, given the space constraints of this little tome and in the hope that your attention span will appreciate a short summary, here is our stab at precisely that:

- **Emphasis** – Or 'focal point', as it is referred to elsewhere in this book. This is all about dominance and influence in a composition. Most artists position their focal point slightly off-centre and balance it with some lesser elements to maintain the viewer's interest. Some artists deliberately avoid emphasis in their compositions. They want all parts of the work to be equally interesting.
- **Harmony** – As in music, complementary layers and/or effects can be joined together in a drawing to produce a more attractive whole. The composition is complex, but everything appears to fit with everything else. The whole is better than the sum of its parts.

- **Unity** – When nothing distracts from the whole, you have unity. However, unity without variation can be uninteresting – like driving on a very straight road through a flat, bleak and featureless landscape. Unity combined with diversity generally has more to offer, both in art and in life in general, of course! Having said that, some very minimalistic art can be very calming and at times even very evocative. For example, when drawn well, a simple landscape can have a very powerful effect.
- **Opposition** – The use of contrasting visual concepts. The boring, straight road referred to above suddenly becomes very dramatic and expressive if a storm builds and explodes above it.

So, these are the fundamental principles of good composition – but remember that in drawing, principles can essentially grow out of any artistic device that is used to produce an effect on the viewer.

Beyond these broad, fundamental concepts, it is also important to bear the following points in mind if you want to succeed in producing compositions that are really effective:

- **Balance** – The consideration of visual weight and importance. This is a way to compare the right- and left-hand sides of a composition. Because symmetrical balance often looks stiff and formal, sometimes it is called 'formal balance'. Asymmetrical balance is more interesting. In this case, both sides of a composition are similar in visual weight but not exactly mirrored. This

is a more casual, dynamic and relaxed form of balance, which is often known as 'informal balance'.

- **Variety** – You create variety in your compositions when elements are changed. Repeating a similar shape but changing its size can provide variety and unity at the same time. Keeping the same size, but changing the colour of the object can also create variety and unity at the same time. In visual composition, there are many ways you can change something while simultaneously keeping it the same.

- **Depth** – Effects of depth, space and projection towards the viewer add interest to any composition. Linear perspective in the real world makes things look smaller in the distance. Some artists try to avoid depth by making large things duller and small things brighter, and so on, to make the objects contradict a realistic impression. Picasso is a good example of an artist who did this regularly in his work.

- **Repetition** – This can be used on all the visual elements of a composition. If things are repeated without any alteration they can quickly become uninteresting and unengaging to the viewer. However, repetition with variation can be both interesting and comfortably familiar. Repetition in a drawing creates movement.

Seeing and Drawing Lines

If you stop and think about it, nearly all drawings are made up of lines. Unless you adopt the unusual 'pointillist' technique beloved of some 19th-century artists such as Georges Seurat, in which, put simply, thousands upon thousands of dots were used to create an image, you are bound to compile your drawings using lines.

There are lots of different kinds of line. There are straight lines, angled lines and curved lines and of course they can carry any number of different thicknesses or weights. Lines can be drawn thickly, thinly, boldly, subtly, lightly – any number of different ways, really.

Lines can be used to separate the individual elements within drawings, or can be drawn tightly together in order to create shading. The ways in which lines are drawn can create different illustrative effects and inspire a range of emotions in the viewer. Whatever you draw and however you draw it, you need lines to define the essence of your composition. You can also use them to highlight details or small sections within your drawings.

Drawing straight lines

If you plan to draw buildings, furniture or anything else with a geometric shape, you will need to be able to draw straight lines. Like every kind of line in drawing, straight lines come in lots of different forms. They can be thick or thin, long or short and they can be drawn in any direction. The basic types of straight line that are available to the artist are as follows:

- **Vertical** – These are lines that are drawn straight up and down and at a right angle to a level surface. Vertical lines reflect strength, grandeur and elegance.
- **Horizontal** – These are lines that run parallel to the horizon, hence the name. They run at right angles to vertical lines and reflect stability, peace and tranquility.
- **Diagonal** – These are lines that are not vertical or horizontal but instead slant at various angles. Diagonal lines give drawings a sense of movement and can convey power.

There is a lot to get to grips with when you first begin drawing, so learning to draw freehand straight lines might be fairly daunting. Some people are naturally better at doing this than others, but if you are not one of them then by all means use a ruler. Just be careful not to smudge lines drawn with a soft pencil as you move your ruler around your composition.

If you feel reasonably confident about drawing a straight line without a ruler, then it is always preferable if you can do so. You will feel less constrained and your sketching will be more fun if you can manage without one. With practise, you should be able to master the skill involved in drawing freehand straight lines fairly quickly. Follow these three simple tips and try drawing some straight lines in your sketchbook.

1 Draw two dots on the page, one where you want your straight line to begin and another where you want it to end.

2 As you draw the line, in your head visualize it
 connecting the two dots.
3 Now connect the dots.

Some people find it easier to draw a straight line in one
fell swoop, moving the pencil with the entire forearm, not
the fingers or wrist. Other people prefer to use a series of
stroking movements to create the line. Experiment with
both methods until you find the one that you are most
comfortable with.

Shapes with straight lines

Once you have mastered drawing straight lines, try
drawing some different shapes, such as squares, rectangles
and triangles. This will involve creating 'angle' lines, which
are formed whenever two straight lines meet in a drawing.
Angles can be of any size and they determine the shape
of the object being drawn. You can combine angles in
any number of different ways to create different shapes.
In drawings they denote characteristics such as strength,
solidity and movement. If you combine angle lines with
geometric perspective, a three-dimensional effect can be
achieved in the drawing.

Take your time and create some cubes and boxes using
angled lines, as well as straightforward flat squares and
rectangles. When you become comfortable with drawing
some basic shapes, try to elaborate them into pieces of
furniture or other household objects. It takes practice to
get the perspective right, but once you get the hang of
drawing your lines straight and with angles that work
correctly, you will not look back!

Drawing curved lines

Curved lines occur when straight lines bend. They can be thick or thin, dark or light and they can change directions as necessary. To illustrate the latter point, think of the letter 'S'. This is a perfect example of a curved line that changes direction. When a curved line does this, in artistic circles it is known as a 'compound curve'. Draw some random swirls on the pad in front of you. These are compound curves.

Curved lines typically reflect beauty, calmness and serenity. They can be very graceful. Most likely you will use lots of curved lines in your drawings. You can use them to create contours in your drawings of objects, and to create shapes. This is because whenever one end of a curved line meets another, it creates a circle or an oval – or at least something approximating one of these two shapes.

Combining different lines

If you look at the things around you as you read this, you will doubtless find that many of them are made up of lots of different types of line. For example, maybe there is a large vase or planter somewhere in the room in which you are sitting. By its very nature, it will most certainly include curved lines, denoting its basic shape, but are there any straight lines in it as well? Perhaps there is a collar or an inset groove at the neck. If so, this has almost certainly been formed by one or more straight lines.

Mixing up lines can be daunting for the inexperienced artist. By the same token, a complicated object might

appear overwhelming. Which lines should you begin with, the straight ones or the curved ones? How do you combine the different kinds of lines effectively?

The answers to these questions lie in knowing where to look for a line in an actual object. It also requires an understanding of how negative and positive spaces meet to form lines on the edges of objects. A positive space is the space occupied by the drawing subject, whereas a negative space is the background behind that subject. Get used to identifying the lines that define the subject and those that suggest the background, and you will begin to see objects with a clearer perspective and a clearer head. Then it should be obvious where to begin drawing and how to combine your lines.

Using a Grid

Once you get used to the idea of seeing positive and negative space as you look at objects, the next trick in refining your perspective is to identify the different types of lines and shapes that make up your subject. You need to get into the habit of visually exploring the edges of the object. Look for horizontal and vertical lines. Are they curved or straight? If they are curved, which way do they curve? Spend some time analyzing how and where lines meet in order to form angles. Look for compound curves. Are there any curved lines that change direction? Carefully consider the outlines of shapes that are formed by different lines meeting. Can you see any circular, rectangular or oval shapes in the object you are proposing to draw? It can be quite hard to do all this simultaneously when

you are starting out in drawing and just beginning to learn how to assess things visually in this new fashion. One way in which you can simplify the process is by using a simple grid. This will enable you to break your subject down into a series of component parts, sections of which can be drawn one by one into individual squares on the grid.

Making a grid

Artists have used grids for centuries in order to study and improve their understanding of perspective. Some of the greatest paintings in the world were created using a grid. Vincent van Gogh's painting of his bed in the asylum at Arles is a classic example. This is a painting that has sold for millions of pounds in the past, by one of the greatest artists who ever lived. If a grid was good enough for Van Gogh, it should certainly be good enough for us!

You can buy grids in a variety of sizes from most art shops, but it is far more fun and rewarding to make your own. All you need is a sheet of transparent plastic marked in squares sandwiched between two simple cardboard frames. See illustration on page 44. This homemade grid is as simple as it looks. Use a ruler or straightedge to mark out the squares in ink on the transparent sheet.

1 Divide the screen into 2cm ($^3/_4$in) squares, about along the vertical axis and the same number on the horizontal.

2 Cut out the two cardboard frames, ensuring that their internal edges are of slightly smaller dimensions than those of the transparent sheet and their external edges slightly bigger.

3 Now glue the transparent sheet carefully into place between the two cardboard frames, front and back.

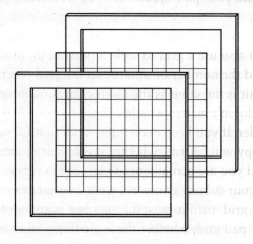

Et voila! A simple drawing aid that will probably transform your drawing experience.

Drawing with a grid

Using a grid is easy and it will improve your drawing. The main purpose of a grid is that it will enable you to get things in the right place. This applies whether you are drawing a still life, a portrait or a landscape composition. If you hold up your grid to view a large scene, you must remember that for any particular picture you should always hold it at the same distance from your eyes and line it up exactly on the same detail each time.

The trick is to lightly sketch pencil lines onto your pad that correspond with the squares on your grid. Make sure you draw the same number of squares, though! You can then make accurate sketches simply by matching what you

draw onto your pad squares to what you see in your grid squares.

You can also use a grid to scale a portrait up or down. Provided the number of squares on the grid you place over a portrait is the same as the number of squares on your pad, it doesn't matter whether those on your pad are larger or smaller. If you keep everything in its rightful square, your copy will be true, whether it is bigger or smaller than the head you are actually drawing. Just to refine this point, if, say, your subject's nose occupies 2½ squares on the portrait grid, then it must fill the same number of squares on your pad grid, whether these are larger or smaller.

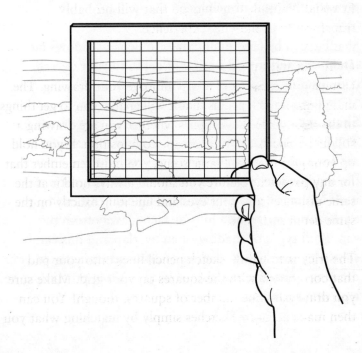

Using a grid isn't cheating – on the contrary, it will help teach you to build your compositions up bit by bit and it will increase your confidence when it comes to understanding both perspective and proportions.

Drawing Light and Shadows

An important factor in adding depth, perspective and realism to your compositions is gaining a proper understanding of how light and shadows work in drawings as you begin to master your technique.

Entire books have been written about the subject of light and shadow in illustration, but here we only have space to give you the basic principles.

Shading can be used in drawings to depict shadows on landforms and to add a sense of depth to your overall composition.

Shadows

There are basically two types of shadow in drawing: cast shadows, in which an object obstructs light and creates the shadow itself; and in shadow, in which the object itself is already away from direct sunlight. An example of the latter might be a hillside facing away from the sun. Both types of shadow often overlap and this can be shown by overlaying shading of different strengths in your drawings. Shading can also be used to show protruding or receiving surfaces.

Tone

Another word for tone is contrast, an understanding of which is vital in your progression as an artist. Think of your television set and how contrast works in the pictures you view on it. A desert scene in strong sunlight produces very high contrast, with jet black shadows and glaring highlights separated by an infinite variety of greys. If the sun was not as strong, you would see lower contrast, in which a range of mid-greys would be visible.

In contrast (maybe an unfortunate term to use while as others describing tone/contrast), a high-key (bright) scene such as a snowscape contains mainly pale tones with less contrast in the image overall. A low-key (darker) picture will have mainly dark tonal values. Key and contrast both add mood and a sense of time to your compositions.

The position of the light source

Where the light is coming from has a huge bearing on the nature of your composition. Outdoor daytime scenes have only one light source – the sun. If you are drawing a landscape, ensure that you know the sun's position and where the light source is coming from. In this case it is vital to ensure that each element of the picture is lit from precisely the same direction.

LIGHT SOURCES AND VALUES

Getting light and shadows right in your drawings takes a lot of practice. Before you can draw the appropriate values that illustrate areas of light and shadow, you need to identify the following and ask yourself these questions:

- Light source – This is the direction from which a dominant light originates. The positioning of the light source affects every aspect of the drawing. When you are looking at an object, ask yourself where the light source is coming from. Also, look for the lightest areas on the object. The very brightest of these are called highlights.
- Shadows – These are the areas on an object that receive little or no light. As we saw above, there are two types of shadow – cast and extant. When you're looking at an object, you need to consider where are the 'dark values', those areas that are in extant shadow? Identifying these will help you locate the position of the light source.
- Cast shadows – These are the dark areas on an adjacent surface where the light has been blocked by the solid object. The section of cast shadow closest to the object is usually the darkest value in a drawing. Once again, by finding an object's cast shadow you can easily identify the direction from which the light source is coming.

When drawing still life objects or portraits, the position of the light source can significantly affect the degree to

which the subject appears to be three-dimensional. A light
source shining directly from behind or in front of an object
or person will create stark, flat shadows or none at all.
Conversely, a light source depicted coming in from the side
of the composition, or from above or below the subject,
will cast softer, deeper shadows that add perspective and
three-dimensionality to the drawing. There is more on this
subject in Chapter 6, 'Drawing Still Life'.

Seeing and Drawing Shapes

We touched on seeing and drawing shapes earlier in this
chapter, but now it is time to explain how to bring three-
dimensionality to the basic shapes that you practised
drawing earlier.

If you look at any large object, and many small ones
for that matter, you will see that it is made up of lots of
different shapes, including circles, squares and triangles.
In order to make these shapes leap off the page and
become more realistic, you need to use shading to
increase their three-dimensional qualities and turn them
into objects such as spheres, cubes, cones and cylinders.

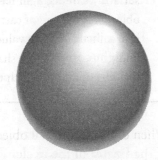

You can create highlights
in your drawings by using
graduated shading. In the
illustration right, you can see
that the shading begins with
very light values. They then
graduate from light to dark.
Less light reaches the other

surfaces of the sphere that are closer to or in the shadowed areas. This increases the sense of three-dimensionality in the drawing.

You can do much the same thing using shadows. The effective use of these will make your drawings look much more realistic. The shading in a cast shadow will always be darker closer to the object that is casting it and will become gradually lighter as it moves outwards.

We don't have the space to go into much detail about drawing different shapes here, but why not try this simple exercise for drawing a sphere:

1 Take a piece of paper and draw a circle towards the top right corner.
2 Now draw an oval shape (an ellipse) to represent the cast shadow of the circle you have just drawn. See the illustration on the left, above.
3 Rub out the part of the ellipse that is inside the perimeter of the circle.

4 Take 2H or HB pencil and draw the light values onto the sphere. The light is coming from above the circle, positioned to the right.

5 Add in the middle light values with a 2B pencil and then use a 6B pencil to draw the dark shadows on the sphere.

6 Gently rub out the line of the ellipse so that it won't stand out too much when you complete the shading of the cast shadow.

7 Use a 2B and a 6B pencil to complete the shading of the cast shadow. This should be darker closer to the sphere and lighter in value towards the outer edges of the shading. See the illustration below.

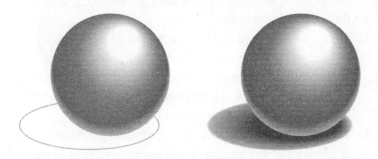

Shading, Hatching and Crosshatching

As we explained earlier in this book, you should begin any drawing by mapping out the basic shapes of your subjects and then finalizing their outlines. Once you have done this, it is time to add the magical effect of three-dimensionality by using shading. The two most commonly used techniques in shading are known as hatching and crosshatching.

These have been used by artists for centuries to make their compositions look more three-dimensional.

Hatching

Hatching is a series of lines, known as a 'set', that are drawn closely together to create the illusion of light values. This very simple method of shading can produce a complete range of different light values in your drawings. There are three key aspects to hatching that will affect the final outcome in your composition. They are:

1 How close the lines are together. In general terms, the more tightly you draw the lines together, the darker the light value will be.
2 How you hold and apply your pencil or pen. The tighter you grip your pencil and the harder you press down with it on the paper, the darker the light value will be. Conversely, if you press lightly and loosen your grip little, you will create lighter values.
3 The hardness or softness of your drawing medium. We looked at the hardness and softness of pencils in Chapter 1. If you use a 2H pencil you will get light marks, a 2B works well for medium light values, and a 6B creates dark light values.

Experiment with different forms of hatching using different pencils. The key is to try drawing your lines closer and further apart in a number of different samples. You will soon realize that the closer your lines are together, the darker will be the effect you create. You can draw hatching lines that are both straight and curved – it's entirely up to you. There is also no limit to the

length or shortness of the lines that you choose to use, but every different type will create a different shade of grey.

It's not easy to perfect hatching, so don't be disappointed if your early efforts do not match up to your expectations. Just keep experimenting and trying different ways of applying this technique. You will soon get the hang of it and should find pencils and effects that become favourites in your drawings.

Graduating your hatching

A graduation (or graduated values, as they are sometimes called) is a continuous progression of light values. Put simply, graduating your hatching means applying lines in different weights, so they go from darker and heavier to lighter and thinner, or vice versa. This creates an effect of different shades of grey within the same patch of hatching. The pencils you choose to use will play a big part in how effective your graduating becomes, and again the only way to become skillful in your graduating is to practise as much as possible.

Crosshatching

This is a technique for rendering shading in drawings, which involves one set of lines crossing over with another set, hence the name of the technique. This is also known as overlapping. You can create an infinite range of light values using crosshatching in your drawings. Once again, there are very few hard and fast rules about how to apply crosshatching. Your sets of overlapping lines can cross one another at any angle. Just as with hatching, three key factors

affect the value that you create with your crosshatching: the density of the lines you draw; how you hold your drawing medium; and what medium you choose to use.

Crosshatching has long been regarded as the king of shading techniques. It has been used for centuries and was a key weapon in the armoury of some of the greatest ever artists, from Michelangelo and Leonardo da Vinci in the 15th and 16th centuries, to Edgar Degas in the 19th century.

WHICH IS BEST, HATCHING OR CROSSHATCHING?

- Hatching is easier for beginners, because it only involves one set of lines.
- Hatching is great for rendering realistic linear textures, for example animal fur, wood or human hair.
- Crosshatching is good for smooth or shiny textures, such as glass, water or human skin.
- Crosshatching offers greater versatility as a shading technique, because it gives the artist more control over where to apply light and dark values.
- Crosshatching is better for graduating effects, as it generally provides a smoother transition from one light value to another.

You can create wonderful effects using crosshatching, and there are lots of different ways of applying the pencil or pen strokes. Some people prefer to move the paper around as they draw so that they are always drawing in the same direction. Other people are comfortable changing directions with their hand and crossing their lines from all

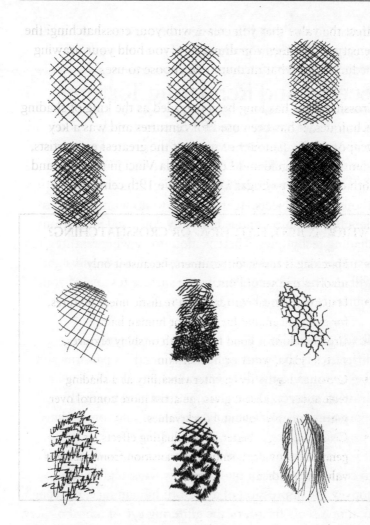

sorts of different angles. See the illustrations above for a selection of values using crosshatching.

Once again, our mantra here is practise, practise, practise! Use lots of different media to try drawing crosshatched

lines in all kinds of different densities. Just as with hatching, experiment with the graduation of your lines as well.

Seeing and Rendering Textures

If you want to make your drawings look truly realistic and leap off the page for the viewer, you need to know how to identify and render – or create – texture. Textures provide the viewers of your drawings with invaluable information about their subjects. Texture is all to do with the surface detail of an object and is normally conveyed via various shading techniques. There is more to viewing texture than a simple visual message; your senses of touch and sight will also help you to identify the surface texture of your subject before you begin to draw.

Texture should not be confused with pattern. The difference is that your sight alone identifies patterns and they amount to the different values or colours of your drawing subject. Once again, patterns are normally represented in a drawing by a series of lines or shading.

If you are drawing an animal with a furry body, you need to convey texture. In the same way, you might want to convey the impression of a smooth human face, the rough skin of a scaly lizard, or the glittering eye of a bird of prey. Imbuing your illustration with texture will enable you to do all these things.

Different textures
The diversity of nature and the world in general is such that there are a huge number of different textures. The

56

artist needs to understand these if they are to bring realism and life to their drawings. Most textures fall within the following categories:

- **Rough** – In a rough texture, the surface features are visible. When you touch them they feel uneven, irregular or jagged.
- **Smooth** – Smooth textures have few or no surface features. However, you might want to convey them dry, dull and matte, or alternatively wet and glistening or shiny and soft.
- **Shiny** – Highlights are generally used in drawings to convey shininess, as light reflects off the surface of shiny or highly polished items such as coins.
- **Dull** – Also referred to as matte in the world of art, objects with a dull texture nevertheless often feature additional characteristics, either rough or smooth.
- **Jagged** – The surface of jagged objects normally has sharp points protruding from it. A cliff face is a good example of a jagged surface.
- **Furry and hairy** – The textures of fur and hair are multiple and very diverse. You need to learn lots of different techniques to be able to convey the difference between soft and coarse fur or hair, fluffiness or frizziness.
- **Glistening** – Similar in nature to shininess, when an object has a glistening surface, its highlights sparkle and shimmer.

How do I convey textures?

Texture is normally represented in drawings with shading. The abiding principle is always to keep the shading as simple as possible. Try to avoid getting caught up in

intricate details and instead concentrate on the essence of the texture that you are trying to recreate.

The trick lies in trying to translate what you know you would feel in touching a certain texture to how you convey it on the page. This takes lots of practice, intuition and self-knowledge, but it is worth persisting with the shading techniques that will bring this quality to your drawings, as only then will they become more realistic. Observe the texture of the subject you wish to draw very carefully, and then decide which shading techniques will work best to convey this on paper. Use the hatching and crosshatching techniques outlined earlier in this chapter and follow the following tips for guidance:

- Look for the intrinsic shapes and forms in your subject, created by the light and dark values therein.
- Look for lines of whatever shape, and decide whether these will be best conveyed by hatching or crosshatching.
- Examine the highlights and shadows in your subject as these will help you to define its texture.

Then, the rest is down to you! Good drawing is all about feel and interpretation. This comes from within you and seldom is it required more than when you are trying to convey texture. But persevere and you will succeed!

Understanding Perspective

We round off this long chapter with a brief discussion of perspective. A grasp of how perspective works and how

it should be applied in drawings is vital to becoming a halfway decent artist. With the correct use of perspective, your representational drawings will become visually accurate and more realistic. As before, with many of the other techniques we have explored in this chapter, they will also become more three-dimensional.

Good artists can create an illusion of three-dimensional spaces on flat pieces of paper. Have you ever seen a still-life drawing that looks so realistic that you feel you could reach out and touch the illustrated object? We bet you have. Similarly, have you ever seen drawings or paintings of landscapes or cityscapes that are so realistic they look as if you could walk through them? Those effects were created through the skilful application of perspective. You too can learn how to use perspective in this way in your own drawings. Read on ...

Geometric perspective

As a child, you were probably taught the basic principle that when things are further away they appear smaller than they really are. It can take a while to grasp this concept and children are sometimes surprised when they see an object close-up for the first time and realize that it was much bigger than they initially thought! This writer grew up in the countryside and had a problem with cows and sheep in this respect for a number of years!

In drawing, a technique known as geometric or linear perspective is used to create this effect. It can also be used to create the illusion that the viewer is either above or below the subject of a drawing. Above all, geometric

perspective adds three-dimensionality to drawings. There are four key strands to geometric perspective, as follows:

- **Horizon line** – Also known as 'eye level', this is an imaginary horizontal line which divides your line of vision when you look straight ahead. Objects that you see below this line are below your eye level, and objects that you see above this line are above your eye level.

- **Perspective lines** – These are straight lines drawn at an angle from the edges of objects which ultimately converge at a point on the horizon line. These lines are used in drawings to establish guidelines for proper perspective.

- **Angular lines** – These are also straight lines, but they run neither parallel nor perpendicular to the horizon line.

- **Vanishing point** – The vanishing point is the place on the horizon line where the angular perspective lines of an object continue past its edges and eventually converge. The closer an object is to the vanishing point, the smaller it becomes, until it eventually seems to disappear completely, hence the name of this device.

You should always draw your horizon line parallel to the top and bottom of your drawing space, assuming it is in the conventional shape of a square or rectangle. The viewer's eye level is determined by your choice of the position of your horizon line. By deciding at what level to position your horizon line, you control whether you want viewers to feel as though they are above, below, or at eye level with the objects depicted in your drawing.

By the same token, you should define your vanishing point clearly by ensuring that your objects' perspective lines recede in the correct way and to the right part of the illustration. Finding and properly positioning a vanishing point will allow you to draw your subjects more realistically and in the correct perspective.

Seeing things differently with perspective

There is every chance that you have found the preceding information about perspective quite technical and confusing. That's because it is! Once again, entire books have been devoted to this subject alone, and artists have agonized about the rules of perspective for many centuries. There is an awful lot to cover and here we only have space for the basic principles involved.

You will naturally learn perspective as your drawing skills improve, but weirdly, drawing in proper perspective will require unlearning some of what your brain currently knows about what it sees and readjusting your visual perceptions to a different set of rules. For example, when you look at a cube you see only three sides of it at any one time, unless it is made of clear glass. Yet you know that the cube consists of six sides! In order to draw a cube accurately, you must record it as you actually see it, not as your mind knows or perceives it to be.

Arranging drawings with perspective in mind

As you begin to understand perspective, you will discover how to draw objects at the sizes you actually see them instead of at the sizes that you really know them to be. Creating an illusion of depth in your drawings is all about

using size differences, overlapping and careful arrangement of subjects to achieve the correct perspective overall.

As a general rule, you should position larger objects at the bottom and in the very foreground of your compositions, medium-sized objects in the middle and to the right- and left-hand sides of your drawings and smaller objects towards the top and in the background of your compositions. It's a simple way of putting it, but doing this will immediately add depth to your drawings and create a natural sense of perspective.

You will find more on perspective in the later chapters of this book, in which we examine methods for drawing different subjects, from landscapes to buildings, people, animals and still-life objects.

Finally, here are some brief, useful definitions of the principal types of perspective – those which you are most likely to hear being bandied about if you attend an art class to brush up your skills. Who knows, you might be able to impress your friends by parroting these out loud!

THE DIFFERENT FORMS OF PERSPECTIVE IN DRAWING

- **Perspective** – Any system used to represent depth or space on a flat surface by reducing the size and placement of elements to suggest that they are further away from the viewer.
- **One-point perspective** – A frontal, head-on view with a central point at eye level at which all receding parallels appear to converge and vanish.
- **Two-point perspective** – A way of representing space on the picture plane in which physically parallel elements of the same size appear progressively reduced along converging rays to the left and right, reaching a single point on the horizon on both the left and right side.
- **Three-point perspective** – A system for representing objects in space with exaggerated three-dimensionality, through the use of three perpendicular sets of converging parallels.

Chapter 3

DRAWING LANDSCAPES

For many people, the fun really starts in drawing when they head out into the great outdoors to begin tackling landscapes for the first time. Drawing landscapes is a great way both to appreciate and accustom yourself to the solitary nature of this hobby. You can get out into beautiful countryside, breathe lots of fresh air and see and experience wonderful things while drawing them. You can even combine your drawing expedition with plenty of exercise, as you stride across fields and up hills in search of the perfect vantage point!

Lots of hobby artists begin by drawing landscapes. This is partly because of all the benefits outlined above, but also because landscapes offer an opportunity to create generalized representations of large-scale, sweeping vistas that do not necessarily require an instant grasp of detail, perspective or shading. If you think about it, nobody views a drawing or painting of a landscape in the same way that they do, say, a portrait or a still-life drawing. The average scrutiny of a drawing of a landscape will probably take

account of things like light and shade, but it is unlikely
that your viewer will check the shape of every tree, bush or
dry stone wall to ensure that it has been drawn correctly.

So, pack up your pad, easel (if you have one) and drawing
materials in a sensible waterproof holdall, pull on your
coat, kiss your other half goodbye and off you go!

What to Use

If you're planning on getting out and drawing lots of
landscapes, you will need to travel light. The good news is
that landscapes look particularly attractive in plain black-
and-white; for centuries many have been drawn this way
and there are numerous classic examples of landscapes
in plain pencil, pen or charcoal that evoke enormous
emotional power and charm.

Pencils and paper

Drawing pencils graded 2B and 4B are ideal for sketching
landscapes. Combine these with an A4 cartridge drawing
pad – or even just good-quality photocopier paper, which is
cheaper to buy by the ream – and you have all that you need
to get started. If you want to be a little more ambitious, you
could try a very soft 6B pencil on good-quality cartridge
paper. The soft B range of pencils can provide rich, rough,
textural effects and striking tonal variations in drawings of
landscapes. The trail of graphite that such pencils leave on
the paper can be smudged to create depths and highlights,
as well as a sense of action and movement. The beauty of
drawing with pencils is that it is easy to erase your mistakes.
And you will make plenty ... There is an old saying in art

that the artist who makes no mistakes makes nothing, and unless you are exceptionally talented, this statement will apply to you. So, carry a soft eraser with you at all times and expect to use it.

Pens

In the past, artists would use black ink together with a variety of nibs to create their drawings, but these days life is much easier for the wannabe landscape depicter, due to the wide availability of a huge range of ready-made pens. You can purchase these from any art shop or stationers and a small selection graded 0.1, 0.5 and 0.7 should more than suffice for most of the landscape drawing you plan to do. The numbers quoted above denote the thickness of line that you will achieve with the pen in question. A 0.1 pen will give you a very fine thickness of line, with 0.5 a little heavier and 0.7 bolder still.

Although these pens are relatively cheap and designed to be thrown away after a little while, they will generally give long and reliable service. One pen will normally contain enough black ink to make dozens of drawings for very little outlay.

Some pen inks can be rubbed out, if you buy the right eraser. Ask your local art shop for advice. Again, you will make mistakes, so if you are planning to draw in pen it is a good idea to use inks that can be easily amended.

If you want to create different effects, you could try using an old-fashioned dip pen with a nib and a bottle of ink. These tend to be more expensive than throw-

away pens and there is the implicit disadvantage that it is much harder to correct mistakes made with liquid ink. However, you will be able to achieve some stunning, more detailed effects with a dip pen and ink used on a good quality cartridge paper. Just try not to spill the ink all over yourself in the process!

Charcoal and pastels

Finally, if you have room in your bag and not too far to walk, why not try using some charcoal and some blended pastels on cartridge paper for some of your landscapes? These media create wonderful hazy effects and will give you the opportunity for much broader experimentation. As with any other area of drawing, practise is the key when it comes to representing realistic landscapes, and the more different media you can try, the better. Familiarize yourself with lots of different combinations of surfaces and drawing media. Once you begin to understand what you can achieve with them, you will begin to find it much easier to select those that are best suited to convey the mood and details of any particular landscape.

Basic Principles

When you are drawing landscapes, the basic principles outlined in the preceding chapter apply as much to this form of the medium as any other. In a nutshell, these are:

- Accurately measuring and creating verticals and horizontals in your drawing.
- Ensuring that the perspective and vanishing points in the landscape are correctly drawn.

- Having proper regard to the size, colour and detail of the various objects in your landscape.
- Investing your illustration with light and shade, while ensuring that the position of the light source is correct.
- Imbuing your drawing with mood via texture, created by shading and other techniques.

We shall consider all these techniques and more when we are discussing how to draw various types of landscape and natural features later in this chapter, but if you feel the need to refresh your memory, turn back to Chapter 2 for a general discussion of these key elements.

Start simply

As is the case with all subjects for drawing, you should start out with some relatively simple landscapes. You might choose to do this at home, before heading off into the great outdoors. You could copy a photograph from a book or magazine, or maybe try some sketches from some photographs of your own. Either way, choose something pretty basic, like the landscape featured in the simple illustration below.

To draw a landscape, you need to fill your sheet of paper
with lines and shading, just as you do with any other
subject. In the illustration on page 69 simple horizontal
lines have been drawn at different levels on the paper to
create a sense of basic perspective. The lines that have been
drawn high on the paper denote far-away hills, whereas
those at the bottom of the paper suggest the foreground
of the image, with everything else inbetween representing
the middle ground. The vertical lines in the drawing nearly
all denote the forms of trees. These are more accurately
defined in the foreground of the illustration, where the trees
are more clearly visible, whereas in the middle ground and
distance the tree shapes are little more than basic squiggles.

Now consider this more developed version of the same
drawing, which features simple shading.

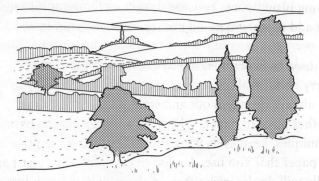

In this version, distant patches of woodland, hedges and
trees have been recorded with vertical, evenly spaced fine
lines. Towards the centre-left of the illustration, light
horizontal dashes have been used to denote a couple of
ploughed fields. Closer up, towards the foreground, trees

have been shaded in with diagonal or simple crossed lines. The former is 'hatching', which was explored in the previous chapter, and the latter 'crosshatching', which again has been discussed previously. More horizontal lines as well as little broken lines and small dashes have been used to create basic texture and depth in the fields in the foreground. At the very bottom of the illustration, you can see little vertical tufts of grass, which draw the viewer's eye into the scene, making them feel as if they are about to walk through the landscape before them.

Filling white paper and understanding blank spaces

Many amateur artists are nervous about filling up the acres of white paper that yawn before them as they embark on a new illustration. Don't be. Always remember that the simplest of lines and shading can be used to create dramatic effects. The key thing is to cover the entire sheet of paper, leaving blank spaces between your lines and textural areas that add depth and mood to the overall illustration.

Get used to experimenting whenever you can. Don't worry about making a mess of your illustrations – you can always rub them out and start again, or just grab another piece of paper. When you are learning the basic techniques, keep everything simple, including the price of the paper that you use. A ream of cheap photocopier paper really will do the trick when you're trying out with lots of different drawings.

The value of volume

Bashing 'em out really is the key! As with just about anything else in life, the more you draw, the better you

will become. Remember what the great South African golfer Gary Player once said – 'The harder you work, the luckier you get'. Well, the same principle applies to drawing. It is no use simply turning out three or four highly-polished illustrations every week. This might sound harsh, but at the outset they probably would not be very good anyway! It is far better to knock out three or four illustrations per hour instead. This way you will perfect your techniques, slowly but surely, while coming to a greater understanding of the basic principles of drawing that form the backbone of this entire book. There is absolutely no reason why you should not do this whether you are outdoors working with a pad or easel or in the comfort of your own living room with a sheet of A4 propped up on a magazine on your knee.

One good way to get in the habit of producing lots of different illustrations is to time yourself. Set a limit of say, a quarter of or half an hour, after which set your paper aside and begin another drawing. Alternatively, ask someone to give you a nudge every now and again, to remind you to move onto another illustration. Always date your work, because when you look back you will be amazed by the progress that you have made in just a matter of weeks. This will not be the case if you confine yourself to only a handful of drawings every month ... Remember, 'the value of volume' – bash 'em out and you will get better!

Simplify for the best effects
When you first begin drawing, there is a tendency to try to include every last detail in your illustration. This is a very common condition among amateur artists. The syndrome is probably largely due to a lack of self-confidence, because

when you first begin, it is hard to know what you should put in and what you should leave out! However, when it comes to landscapes your drawings will fail if you attempt to include too much detail. While a camera will record every last facet of what is presented before its lens, you have the luxury of choice, which comes with the power of thought. Indeed, many of the greatest drawings and paintings of all time are really all about what the artist has chosen to leave out as opposed to put in. There is great skill in suggesting what things are like visually while using as few lines as possible.

Nobody is expecting you to become Leonardo da Vinci overnight, but never forget that as an artist you have a tremendous amount of both freedom and control. Freedom, because you can decide which trees, buildings and streams to include in your illustration and which to leave out; control, because if you put something into your drawing that simply does not work, you can always take it out again!

As we say time and again elsewhere in this book, you are the boss in drawing and this is partly what makes it such a wonderful hobby. You must have the self-confidence to create your own style and way of doing things. Develop your own way of drawing horizontal and vertical lines, by changing their weights or by breaking them up. Be audacious and cross lines when maybe you think you should not. Experiment with shading until you find the particular style or technique that reflects your mood and feelings. This is how you will define the unique personality of your illustrations. And ideally this personality should always reflect your own.

So, when you are drawing landscapes keep the famous 'KISS' principle in mind: KEEP IT SIMPLE, STUPID! Repeat the mantras that are at the heart of this little book:

- Be confident.
- Keep it simple.
- Look, look, look!
- Practise, practise, practise!

Trees, Rocks and Natural Features

Once you have drawn some basic landscapes and become comfortable with the principles of creating depth and perspective in your illustrations, you will doubtless want to progress to forming realistic representations of features in the landscape, such as trees and rocks. This will enable you to draw landscapes that are 'closer' to the viewer and that contain more detail. So, if you want to learn to draw trees that don't look like sheep and sheep that don't look like trees, read on!

Trees

The first thing to think about is shape. Is the tree you wish to draw round, tall or very spread out? What do its leaves look like? How dense is its foliage? How much of the branches can you see, what shapes are they and what angles do they form? What is the bark like? Can you sense its texture by looking at it? How will you manage to convey this in your illustration?

These are all problems that you need to solve in order to create a realistic representation of the tree in front you.

As always, the starting point is to have a really good close look at the subject. Only then will you capture its particular character. Once you have decided how you want to depict your tree you can create its outline and begin adding detail. Fine lines should be used to create the trunk, any visible branches, and the definition of the leaves. Dark shadows should be used to give the whole structure depth and form. A few small, fine pen strokes can be used to suggest the grain of the bark. See the illustrations below to give you an idea of how to create all these different elements in conjunction with one another.

Many landscape artists frequently use trees as the focal point in their illustrations. Get used to creating realistic shapes and forms, paying particular attention to the qualities of the bark, the shape of the leaves and the angles of the branches and then begin to make trees the dominant features of your illustrations.

Try drawing lots of different kinds of trees. Draw trees in winter when they have been denuded of their foliage; in summer when they are in flower or fruit; in the

autumn, when they might well be at their most glorious, resplendent with red and golden leaves. Attempt different trunks and leaf shapes and experiment with details individually, rather than just drawing them as part of composite images. Get used to drawing trees at the front of your illustration in lots of detail, and at the back of your illustration as far-away, vague representations.

Practise sketching small clumps of trees, in which separate shapes can be clearly seen, before you attempt larger, more distant tracts of trees. Different species with distinctive shapes in nearby groups can be depicted simply by using shading, or you can stipple and use lines or pattern to add leaf textures. Use different light tones on darker tones to create colour and texture and silhouettes or simple vertical shading of varying heights to represent trees in the far distance.

Rocks and other features

Sometimes a landscape can look really daunting and it can be hard to know the best way to depict it. However, seemingly complex landscape scenes can often be broken down into simple, easily drawn geometric shapes or solids. Here we return to the early guiding principle of this entire book – draw your outline shapes first, always using them as a starting point for what follows. By ignoring or confusing surface detail and shading, you will automatically simplify the process of executing your drawing.

Return to the simple landscape illustrated at the beginning of this chapter. Observe the simple forms and shapes that make up the entire illustration. Now imagine it with a few

more details added, such as rocks and tree stumps – maybe even a few animals. Once you have created a basic, skeletal composition for your landscape, with all its main features in the right positions in relation to one another and drawn to the correct sizes, you can easily add details and refine the basic lines of your structures.

Rocks are a good example of a simple yet effective feature that you can add to increase the level of detail in your landscapes. They are easy to draw, being largely round or oval in shape.

Sketch out the basic shapes of your individual rocks, creating a mound of different sized stones and slabs. Then, add fine lines to suggest cracks, splits and texture. Use heavy infilling (crosshatching) to depict the darkest areas of the rock pile. Also use crosshatching to depict shadow around the mound of rocks. Follow the illustrations below for inspiration.

For more detailed natural features in the foreground of your illustrations, you could try sketching in some sheep or cows. Alternatively, some dead fallen branches or tree stumps could be used to add interest, maybe with a couple of birds or squirrels to adorn them, adding life and movement (see Chapter 4, 'Drawing Animals').

Always try to work as much texture into your features as possible, as this will add mood and atmosphere to your illustrations. You can also do this by working on the light or general aspects of your drawing. For example, an impending thunderstorm will always add great drama and excitement to a countryside scene.

Bridges and Buildings in Landscapes

As you become more confident at drawing landscapes, you will probably want to add more ambitious features such as bridges and buildings. Bridges are particularly useful visual devices that have been popular with artists for centuries. This is because, just as in real life, they join one riverbank to another and convey traffic, in drawings they can be used both as focal points and eye-leading structures, literally taking the viewer from one part of the illustration to another. Buildings come in many different shapes and sizes, and numerous entire books have been devoted to the special skills required to draw them well.

Bridges

Next time you're out in the countryside, find a pretty old bridge and take a really good close look at it. How was it

built? What materials were used? How old is it? What was it used for and by whom? As ever, observation is the key to success ...

There are many different types of bridge. Some are built in the manner of dry stone walls, with numerous unevenly sized and shaped stones making up their bulk. Others have more precisely defined, rectangular shapes. Some are engineered out of metal. When it comes to detail, bridges offer particular challenges. To draw every single stone that makes up a bridge might take you absolutely ages, but then again, will you be able to convey the proper form and character of the structure if you don't do so? The same remark applies to many walls and buildings in general.

Start with a pencil sketch conveying the general shape and nature of the bridge. If you decide that you do not want to include too much detail, position the bridge relatively high up your page so that it sits in the mid- to background of the illustration overall.

Once you're happy with the basic shape of the bridge, you can then either start adding detail to it or place the other features in your illustration around it. In the following

illustration, the skylines were added using a 0.1 pen followed by the distant hill line and then the main bridge construction. The shading details were added last of all. The trees were heavily crosshatched to make them stand out and then the bridge stippled with a fine pen to create the effect of the many stones within it.

DRAWING BRIDGES

• Study the bridge thoroughly from all angles before starting.

• Make a decision about how much detail to include before you begin.

• Only ever attempt to draw every single stone if your illustration is a close-up of the bridge.

• Instead, try using dot stipple to create the effect of the stones on the bridge.

• Use short lines and dashes to create space and depth in your Illustration.

You could attempt a copy of this drawing, using vertical and diagonal lines as well as crosshatching for the shading and dots, dashes and tiny oblongs to record the materials in the bridge. Radiating and broken lines will create an effect of space in the sky. Be sure to draw in tufts of grass and the fence posts in the foreground to add to the sense of depth in the illustration.

Buildings

Drawing buildings is an art in itself! An entire science – architecture – uses this art as its fundamental basis, so it will probably come as no surprise to learn that there are countless different rules about how to draw buildings correctly. For this reason, we are going to cover only the basic principles here.

In order to draw buildings well, you need to:

- Measure the relative proportions of the structure accurately by holding up a pencil and transfer these to the paper in front of you.
- Create a grid on which you can position all the elements that form your subject.
- Use the grid to ensure the accuracy and correct proportions of all your vertical and horizontal lines, in relation to one another.
- Use defined shapes – sequences of cubes, and cuboids (box shapes with unequal faces), tubes or cylinders, prisms and pyramids – to create your buildings.
- Build up your drawing gradually, first adding all the main vertical and horizontal lines, such as doors and windows, and then putting in detail to finish it off.

- Use tones and shading to enhance the three-dimensional forms of your buildings and to represent shadows cast by light.
- Create mood and atmosphere by using light or bold and strong textures.

If you are particularly keen on drawing buildings and landscapes, then consider taking a specialist course in this discipline. Beyond that, get out into rural and urban places and find as many different types of building as you possibly can. Barns, cow sheds, farmhouses, churches with steeples, even old castle ruins – all these will present challenges that will only diminish as your experience in drawing them increases. The more you vary your drawing experience, the more accomplished an architectural artist you will become. Good luck!

Skies and Seascapes

You can get really moody and romantic when drawing skies and seascapes – think Heathcliff on the moors! Seriously, these are some of the most rewarding and exciting subjects to create with pen and paper.

Get in the habit of observing the sky every time you go outside or even just looking out of the window. There are so many wonderful and different shapes of cloud just waiting to be drawn! Sometimes you can see heads and faces in the clouds – who do they remind you of? Well, take your head out of the clouds and concentrate on drawing them instead.

As for seascapes, the world is your oyster. The variety of

the sea is infinite – you will never be lost for a subject if
you go drawing at the coast.

Skyscapes

When you depict the sky in a landscape, you automatically
add atmosphere to your illustration and convey messages
about the weather. Dark shading drawn at a uniform
angle from sky to land will immediately suggest distant
falling rain. The hazy effect of mist will obscure parts of
a landscape, gently diffusing sunlight to render objects
unidentifiable and softening shadows in the process. Bold
strokes drawn in the sky can create the appearance of
wind, and this effect can be enhanced by the inclusion of
some bending trees.

You should always draw a sky palest at the horizon and
darkest at its greatest height, and it should usually be
drawn more lightly than the landscape beneath it. Try
to avoid creating skies that are overwhelmingly dark, as
these will detract from the effects of your overall scene.

Clouds can be drawn to create a huge variety of effects.
They can change very quickly, so if you are working
outside and drawing them from real life, you will need to
get a move on! Observe their many different shapes and
treat them like solid objects on land; begin by drawing
their outlines and then add highlights and details later on.

You can increase the effectiveness of clouds in your
drawing by creating a light source that falls from one
direction, causing textural and tonal values to diminish
with perspective. You do this by using simplified shading

or just a range of light greys. This is also a classic example of when you can use the pure white background of your paper to indicate luminous light shining through or over the clouds that you draw. The heavier your shading, the more imposing your clouds will become. The lighter your shading, the more you will create an uplifting mood and a sense of buoyancy and movement in your skyscape. Vary shadow strengths to match different cloud densities.

THREE TYPES OF SKY TO TRY!

If it's pouring down with rain outside and you are stuck for inspiration, turn on the computer and try to find some images you can copy of the following kinds of sky:

- Clear and calm – You can create the illusion of distance in a clear sky with atmospheric perspective. By graduating shading from very dark at the top of the sky to very light above the horizon line, you will achieve an illusion of depth in your illustration.
- Stormy and violent – Use dramatic, bold shading to create a dark and stormy sky. Have fun creating the effect of lightning by using lighter coloured pencils on your dark skyscape.
- Soft and cloudy – Use clouds to create a calming, picturesque atmosphere. Think of them as three-dimensional objects and observe how light from the sun defines their forms with highlights and shadows.

Finally, a word about colour. Of course, you can use infinite shades of grey to create numerous different effects in your

skyscapes, but if you want to draw dramatic sunrises and sunsets, it is probably time to break out the pastels! Using strong colours and tonal gradations between the dying light of day on the horizon and the dark night tones appearing higher in the sky, you will be able to create fabulous sunsets. Similar effects can be used to create a realistic sunrise. Draw elements in the foreground in subdued detail and limited tonal ranges. This will enhance the representation of dawn or dusk. Objects positioned further away in the middle ground or background of your illustration should be drawn in silhouette.

Seascapes

Water of any kind is one of the strangest subjects of all in drawing. This is because you can't really draw water itself – what you actually draw is usually the light reflected on its surface. Whereas drawing a pond in woodland or a lake surrounded by mountains and trees can be very challenging, due to the number of reflections that you need to draw into the water, seascapes are generally easier to draw. This is because the sea is much bigger and can easily be depicted as having a less-defined area. This means that fewer external objects reflect in the water, which in any case will often have a less tranquil surface and will instead be defined by gentle swells or crashing waves.

The foregoing is not meant in any way to mean that drawing seascapes is less interesting, exciting or challenging than drawing other bodies of water! Quite the contrary. The realistic representation of movement in water is possibly one of the hardest things to capture in landscape drawing. The surface of the sea is animated by a complex mixture of winds, currents and general

turbulence. When these run in the same direction, they generate parallel waves, but when they are opposed, they create irregular, choppy wave patterns. Capturing these effects can be very difficult indeed. However, if you are successful, you will feel an immense sense of pride at creating something that actually looks like the ocean and not what the cat has just had for tea!

If you wish to convey the effect of a gentle current or small waves on the surface of the sea, use short, parallel strokes. To illustrate larger waves at sea, use horizontal, undulating lines to represent their crests. This is where perspective comes into play. The vertical spaces between the crests of the waves will become narrower as the waves recede into the distance. To create the effect of breakers crashing onto a beach, use lots of curved strokes and wavy lines of stippling to mark the extent of the sea foam at the water's edge. See the illustration below to help you with this. You can also use dark and light soft pencil strokes (try a 2B) to create contrast between the waves and to develop the effect of light reflecting off them.

Chapter 4

DRAWING ANIMALS

If you want to make yourself popular with your grandchildren, try drawing some animals. From fluffy kittens to gambolling Shetland ponies and gimlet-eyed birds of prey, everybody loves a good representation of a creature, be it beloved family pet or scourge of the wild.

There are lots of interesting techniques that you can bring to bear when drawing animals, and their facial expressions and bodily movements can be as difficult to capture accurately as those of human beings. This can make animals challenging subjects, but of course there are as many ways to draw them as there are to skin a cat (if you'll pardon this possibly unfortunate analogy!), and you will gain invaluable general practice and experience in doing so.

You could start off by drawing the family pet – if it will sit still for long enough. You would be surprised by how self-conscious household pets can be about being drawn, painted or photographed. Of course you could always

chain it to the sideboard, but this might look a bit odd in the finished drawing!

Alternatively, take a trip down to the local duck pond and try sketching the odd mallard or swan. These birds tend to be fairly languid and move slowly on the whole, which makes them good subjects for an inexperienced animal artist. If you live in the countryside and have a farm nearby, you might be lucky enough to find a sleeping pig, munching cow or leisurely grazing sheep. Again, all these relatively sedentary creatures will help you to perfect your lines and observe animal expressions and movement accurately, without tripping over your pen pot as you try to stay with your subject!

Basic Principles

There are a number of considerations to bear in mind when you begin drawing any animal. In broad brush stroke terms, these are as follows:

- **Choose the right medium** – Have a careful think about how you want to convey the look and feel of the animal you have chosen to draw before you pick up any particular pencil, crayon or pen. Do you want to depict a general impression, or do you wish to show the characteristics of the creature in great detail? For example, a soft pencil or stick of charcoal will create a sense of atmosphere but with little detail, whereas a ballpoint pen used on white card produces fine, crisp lines which are ideal for conveying the twinkle in a bunny's eye or the fine stripes in a tabby cat's fur coat.

- **Look at the creature closely and properly** – Animals, like humans, have very distinct characters. There is a particular 'essence' to every creature, which is conveyed by the way it stands, sits, moves or feeds, combined with any number of distinctive individual characteristics. You won't capture the true 'feel' of a particular animal in your drawing until you have observed it very closely indeed.
- **Physical structure and form** – Once you have had a really good close look at the animal you are keen to draw, some consideration should be given to its overall physical structure and form. Is it a delicate, elegant animal? Is it a bulky, hulking beast? What is the predominant physical characteristic? Fur? Feathers? Bone? Horn? It's worth asking yourself these basic questions so that the emphasis of your drawing is more likely to be firmly on the thing that most defines your animal's form.
- **Behaviour and movement** – All animals behave and move differently and, rather like the individual physical characteristics referred to above, most creatures exhibit a particular type of behaviour that marks them out from other members of the animal kingdom. This needn't be as complicated as you might think, although it can be tricky to convey defining animal behaviour in a drawing until you have had quite a bit of practice. For example, dogs wag their tails – everybody knows that – but how easy is it to get this across in a pencil drawing? The skill lies in identifying the most characteristic form of behaviour of the animal in question and then portraying it visually in the simplest possible way.

- **Proportion** – Any animal you draw will look very silly indeed unless you get its proportions right – the way in which the different parts of the body relate to each other in size and shape. Although, of course in reality proportions remain constant, they may appear to alter according to the artist's viewpoint. For example, if you draw an animal from head-on or directly from behind rather than from the side, you will need to incorporate the visual effect known as 'foreshortening', in which the proportions of the animal are 'telescoped' by the artist's head-on perspective. Don't worry – we'll explore this relatively complex point in detail later on when we are considering how to draw various types of animal.

- **Light and shade** – You need to understand how light falls on birds and animals before you can create the appropriate atmosphere and mood in your drawings. For example, if you're able to cast light from the side of your illustration you will create a sense of evening and calm, whereas a depiction of strong sunlight will highlight your animal figures and make them jump from the page.

- **Texture and pattern** – One of the things that makes animals so good to draw is the fact that they nearly always have interesting fur, feathers, scales, spines or some other intriguing covering or defining characteristic. So much more interesting than boring human skin! In order to recreate fur and feathers realistically you need to decide what kind of texture and pattern you are dealing with and then select the right materials to produce a similar effect.

Try Caveman Art

If you are keen on the idea of drawing animals, it might be fun to start by trying to emulate the very earliest animal artists. Many thousands of years ago prehistoric cavemen made simple but accurate representations of creatures on the walls of the caves in which they lived. The cavemen drew with charcoal (burnt wood), coloured clay, earth and lamp black from their hollowed-out stone lamps. Nobody knows why they did this, or whether those cavemen who created the drawings were the most instinctively artistic of their tribes. Perhaps they wanted to show their peers what kinds of animals were available around them for food? Or perhaps they just gloried in the beauty of the creatures that lived among them. Whatever the reason, what is obvious is that the cavemen artists had supreme observational skills. They clearly looked really carefully at their subjects before recreating their images on the cave walls in remarkably accurate and sophisticated shapes and forms.

You might have a bigger brain than the average Neanderthal caveman artist (or maybe not, as brains do shrink over time!), but if you want to draw as well as him, you will need to know how to *look properly* above all else – for this really is the secret of being able to draw!

Ice Age animals

One of the most popular subjects for Ice Age artists was the bison or buffalo. This animal was widely hunted for food, which probably explains its popularity as a subject for the cave walls. Many of the representations that

survive are very basic, with
few simple lines. You could
try the following illustrations
with a 2B (very soft) pencil
sharpened into a chisel point.
This means shaping the lead
into a wedge so that it has a
wide edge and also a thin side
when it is turned. This creates
a dual-purpose pencil that
enables you to draw both thin
and fat lines. As the pencil is
very soft, it closely replicates
the clay and earth effects
that the cavemen would have
applied to the walls all those
centuries ago.

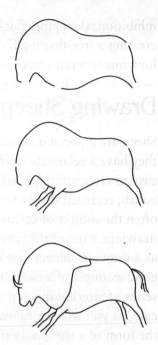

Notice how simple the illustration is, with only a few
details added. It is the confident, flowing shape of the lines
that conveys a sense of movement and evokes a huge,
hairy buffalo pounding its way across the plain.

If you managed to recreate the bison shown above, you
could try a few other prehistoric animals, such as a goat or
a horse. Apply the same simple, bold lines that you used
for the bison. Turn the head of the pencil as you draw to
create a thicker line for emphasis and a thinner, finer line
for detail or maybe the sense of a flailing hoof.

The key thing is to be confident and enthusiastic in the
way that you apply the lines. Cavemen drew without

inhibition, sketching quickly and boldly. Concentrate on creating a free-flowing form, and then it is up to you just how much detail you choose to add.

Drawing Sheep

Sheep are a popular subject for amateur artists, because they have a relatively simple, fluffy shape that is fairly easy to replicate. They are also quite cute, in a rather oafish, retarded way, which means they are also very often the subject of cartoons or caricature-style drawings. One of the reasons we have included sheep as a drawing subject in this book, is because they are a good example of a subject that can be created using a series of interlinking and overlapping basic shapes. In this case, as you will see below from the illustrations below, the form of a sheep is derived from a large rectangle and an inverted triangle. It really is as simple as that! The only thing to bear in mind is that it is important to keep all your lines very light, as many of them will need to be rubbed out before you finish.

Here's how you do it:

1 Draw a large rectangle. Keep the rectangle close to the top right-hand corner of the paper, leaving plenty of room for the legs and head.
2 Draw a downwards-facing triangle for the head. Tip it slightly to the right, cutting into the rectangle.

3 Draw a half circle on top of the triangle to represent the top of the sheep's head.

4 Draw on oval shapes at top left and right of the triangle to represent the sheep's ears.

5 Complete the sheep's face within the triangle, adding eyes nose and chin.

6 Turning to the rectangle, draw a C-shaped backwards-facing line at the right-hand edge of the rectangle to form the sheep's rear end.

7 Add the sheep's legs, drawing an angle into the rear pair (see below).

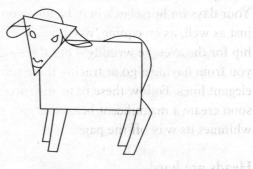

8 Draw three more curved lines around the other three corners of the rectangle to create the rest of the body.

9 Now carefully erase the original lines of both the rectangle and the triangle.

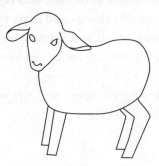

10 Add detail and shading as you see fit (wool, shading on the hooves and in the eyes, more detail in the ears and facial features, etc.).

Drawing Horses

Just about everybody loves horses and for this reason they are a perennially popular subject for drawing and painting. Your days on horseback may be long gone and probably just as well, as an equine 'wobbly' could mean a broken hip for the average wrinkly – but there is nothing to stop you from having a go at tracing these splendid animals' elegant lines. Follow these basic instructions and you will soon create a magnificent beast that practically neighs and whinnies its way off the page.

Heads are hard
Probably the most difficult part of a horse to draw is the head, because equine skulls are an unusual shape that is

quite complex. Rather like your own poor old head, a horse's bonce features many small bumps, hollows, ridges and curves. It's also very hairy (in which respect of course it might differ from your own), and there is a fair amount of detail to contend with if you want to produce something that looks less like a yeti and more like Red Rum.

A horse's head is wedge-shaped, so start with a simple wedge outline like this:

That's obviously the horse's profile, but if you want to draw a horse's head 'head-on', so to speak, then think coffins, although let's avoid thinking about them for too long:

If you can fix both these basic shapes in your mind, you will then be able to draw a horse's head from memory. Of course, there is a world of difference between Ernie the Milkman's old nag and an Arabian stallion, but the basic principle is the same from horse to horse. Think Cheryl Cole and Jo Brand – they might look quite different, but they are both human and female and share the same basic characteristics …

Adding detail

Draw in the main features and then start adding dot stipple to shade in the skin texture. This technique gives depth to the image and suggests bone under the skin. Horses have big eyes, heavy upper eyelids and long lashes. Their cheeks are prominent and they have a long bony ridge down to the nostrils, which are surrounded by soft skin. And nasal hair. Lots of nasal hair. If you need inspiration, watch your nearest and dearest asleep in the armchair for a while. The dot stipple conveys all these features beautifully and brings out the different textures in your horse's head.

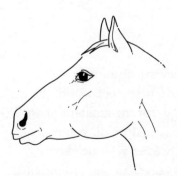

Try these horsey drawing assignments:

- If you have a rocking horse – perhaps you keep one for the grandchildren? – start by drawing that. The beauty of this is that it won't move, bite or kick – unless someone's on it, of course.
- Find a photograph of a racehorse in the newspaper and try copying that. You can put in a suggestion of a background or maybe amuse yourself by getting the pattern of the jockey's silks spot-on.
- If you live near a farm or a country park, try drawing a working shire horse from life. You could include a farm background or similar, or maybe show the horse towing a cart full of beer, depending on your personal inclinations.
- Try drawing a wild pony as a design for a birthday card. You could have some fun trying to emulate the Thelwell-style that you probably remember from your hey (hay-?)-day ...

Drawing Cats

Cats. Love 'em or hate 'em, they are absolutely everywhere. The doyen of the domestic pet world, the cat is the most popular subject of all for the amateur artist. If you think about it, it makes sense. After all, you probably have a cat, and if you haven't, we bet your neighbour has! This means there is always one hanging around, just waiting to be drawn ...

When it comes to drawing, the other beauty of cats is that they spend so much time keeping still – literally sitting and lying around, at least during the day. Of course, at night most cats disappear outside into a dark, mysterious and saturnine world of death and destruction, usually involving hordes of unfortunate small, furry creatures. This probably explains why they're so exhausted during the day and can do no more than lie supine at your feet purring their heads off. However, this, of course, makes them the perfect subject for observation and re-creation on the page.

If you can sketch a cat accurately, then you will be able to draw any creature. A cat's form, behaviour and movement are such that drawing these feline friends regularly will give you a solid grounding in creating good illustrations of other animals.

Let's face it ...

The hardest part of a cat to draw is its face. Unlike dogs, all cats have a similar face. For this reason, people commonly make the mistake of thinking that a cat's face is easy to draw. However, on the contrary, because a cat's skull is actually a very odd shape, covered in fur and muscle, it's much harder than you might think. Get a cat's face right, though, and the rest of the animal should follow easily. For this exercise, we are going to use a simple square grid to fill in the cat's facial characteristics.

In this sketch of a cat's face, the light source is coming from the right, so the shading should be lighter on the right-hand side of the illustration.

99

1 Draw a square grid measuring approximately 25 x 25cm (10 x 10in), incorporating five squares across by five squares down.

2 Very lightly, draw the outline of the cat's fur on the top of the head and around her cheeks and chin.

3 Draw the outline of the cat's eyes and the pupils. Make tiny C-shapes in the pupils, which will become the highlights of the cat's eyes.

4 Draw the outline of the nose and mouth. Observe closely the individual lines that make up the cat's nose. Also, note that the nose is almost the exact width of one of your squares!

5 Carefully rub out your gridlines and redraw any sections of the sketch that you inadvertently erase in so doing.

6 Draw the fur on the cat's ear and the top half of the head (on the left) with short hatching lines.

7 Fill in a few darker areas until you're happy with the look and texture of the fur.

8 Draw the outline of the rims around the eyes.

9 Finish shading the fur of the other ear and the rest of the top of the head.

10 Add shading to the rims around the eyes and shade in the pupils.

11 Complete the details in the eyes.

12 Draw in more fur on the face and neck.

13 Shade in the darker areas in the iris of each eye. Leave a white area for the major highlight and a lighter area on the side of the iris opposite the highlight.

14 Shade in the nose. Leave the highlight areas white to make the nose appear shiny.

15 Complete the fur on the rest of the face and neck and at the whiskers. Shade the neck darker, because it is in shadow under the cat's face. Outline some of the whiskers lightly to make them stand out.

Your cat's face is complete. The smile on the face of a little tiger, or the expression of a more noble beast ...?

Drawing Dogs

Man's best friend – apart from all the walking required! However, if you are getting too slow to keep up with your dog, why not try drawing it instead? The main problem with this concept is that dogs can be very bouncy and restless. They're just not as cooperative as cats when it

comes to keeping still, so it's probably a good idea to accept right away that you might find a dog a lot more difficult to draw accurately.

However, this is not the only challenge when it comes to drawing a dog. Unlike domestic cats, which at least in terms of head and body outline are basically all the same, dogs come in lots of different shapes and sizes. Also, unlike cats, all dogs do not share the same type of skull. Some have deep foreheads while others are streamlined, stubby, extended or some other shape. There are so many different breeds with so many different individual characteristics that it is impossible to generalize about how they should be drawn.

Once again, it all comes down to close observation. You need to look at a dog carefully before beginning to sketch. If you own a dog, you will know it better than any other, so it's best to start with him or her. That's if he or she'll keep still enough, of course! If not, then the best bet is to find some good book or magazine photographs of a particular breed and go from there.

Drawing a border collie

Border collies are working dogs that are full of life and energy. They are also very friendly and fun to be with. Their character and personality make them a good choice of breed to try to capture in a drawing.

Look at the drawing oppposite of an adult dog head. Notice how well-defined the foreheads of the dog's are and their long snouts. A white line has been left around part of the ears

so that their shape can be clearly seen. The black markings, which are usually dense and very black on these animals, should be put in with a brush and black drawing ink.

1 Start with the construction lines of the dog's figures, as shown below.

2 Add in the details as shown, using gentle stippling around the muzzle for the effect of the whiskers.
3 Variable length lines and shading should be used to convey the rough coat of the border collie.

Now we are going to move to a head-on view of the collie at work. People are fascinated by the way this dog

crouches down, moves its head and its paws while working the sheep. It's a challenge to convey the movement and behaviour of the border collie accurately, but by using the technique of foreshortening to balance the proportions of the dog correctly, you should be able to create an authentic look of the dog moving forwards head on.

The easiest way to understand foreshortening is to look at the subject in profile first.

The body shape of the dog is such that it can be viewed as three separate cylinders, corresponding to the head, the main body and the tail. Any cylinder, as it is turned towards us, becomes compressed in shape. In the foreshortened front view below, we can see the border collie becoming a series of concentric circles. Viewed from the front, the head and chest of the dog obscure most of the body and the front legs and feet dominate.

In this three-quarter view, the body cylinder is only partly foreshortened. Seen from this angle, the Z-bend of the rear leg is not visible and is reduced to a knee bulge instead, with the foot of the dog projecting beneath.

With practice, you will master the art of foreshortening, which in this case is the best way to convey the unique forward movement of the border collie dog at work. If you can get your own dog to stand still long enough, you could always try drawing him or her from the front as well ...!

Drawing Birds

Birds might not be the cutest and cuddliest of all creatures, but they make great subjects for drawing. Like dogs, there are lots of different types of bird in many different guises, so you will never be stuck for variety. Birds also offer different characteristics and challenges from the four-legged animals

that we have considered up to now in this book. They have wings, beaks, talons, long scaly legs, plumes and often extraordinary eyes that dart and transfix in ways you will never see in a domestic pet or farmyard beast.

Birds are of so many different shapes and sizes and fly and move in such different ways that they represent the perfect subjects in which to invest individual character. As we have seen previously, their forms also tend to break down into simple, basic shapes that you can easily adopt (and adapt!) as you begin drawing them. To complete this chapter, we are going to show you how to draw three different birds – a blackbird, a seagull and a mallard.

Drawing a blackbird

If you have a garden, the chances are that you will be able to find this bird flapping somewhere around it. Grab your camera and try taking a few snaps of it from different angles. See if you can capture the bird performing different movements, such as pecking at the ground, running across it, preparing to take off and gaining flight. Print off your images and use these as reference points for your drawings. This way, you will get a far more accurate representation of the bird than by observing it and trying to draw it simultaneously.

The simplest way to draw the basic shape of the blackbird is to use the time-honoured artistic device of an egg-shape for the body and a smaller 'egg' for the head, overlapping the body at the neck. The line of the tail can be found by dividing the body longitudinally. The legs emerge from just behind the belly of the bird. Although the bird will

move its head and point its beak in lots of different ways, it will usually carry its head a little upwards, giving it a somewhat jaunty look. Try to reflect this in your drawing. The blackbird's eye is situated above the bill and near the mouth opening.

1 Draw two egg-shaped ovals, adding a line to establish the angle of the tail.
2 The head can now be joined to the body in two flowing lines, from crown to nape and from chin to breast. The wings should be drawn to wrap around the body.
3 Once you have got your basic shape as you want it, erase any unwanted lines and add detail such as eyes and feather forms.

Drawing a seagull

Seagulls are among the easiest of birds to draw, because they have such a smooth, aerodynamic and distinctive outline. The beak, legs and feet are particularly characteristic of the bird. Of course, sketching one of these birds might justify a trip to the seaside for the day!

Unlike that of the more oval blackbird, the shape of the seagull is based on a sequence of triangles. The gull's folded wings form one long triangle, its long neck forms another and its wedge-shaped head suggests a third.

1 Begin your sketch with just three simple triangles, overlapping them to form the basic shape of the bird. Then add a couple of downward strokes to suggest the position of the legs at the bottom of the triangle representing the body.

2 Within the triangles, start to sketch in the wing feathers
 and draw in outlines of the wingtips, which reach well
 down beyond the tail. Now draw in the bill, which
 curves down and reaches back under the eye.
3 Work your drawing up freely, using a fluid line to add
 details such as the webbed feet. If you use a dip pen
 and ink, you can do this easily.
4 Add a wash of neutral tone to introduce shadow and
 colour on the back of the bird. However, leave white
 edges on the bird's feathers.

Drawing a mallard

The local duck pond is a great place to try out your
drawing skills. Ducks are fairly obliging subjects, in that
they tend not to move too quickly. If you can tempt them
with some judiciously distributed breadcrumbs before you
start drawing, so much the better!

There is something particularly rhythmic and spiralling about
the bodies of ducks and mallards which make them especially
rewarding to draw and paint. Unlike the basic ovals and
triangles that you used to define the basic body shapes of the
blackbird and seagull, drawing a duck or mallard requires the
application of two others – surprisingly, a question mark for
the head and a teardrop shape for the body!

You will only get the true character of this bird across in
your drawing by applying bold, sweeping lines. A mallard
is a most curvaceous bird!

1 Start by drawing your question mark for the head and
 your teardrop shape for the body. Then you should

apply a series of spiral sweeps, starting from the eye and going around the cheek, under the chin, over the crown, and down the back of the neck. These lines should be echoed by a wider sweep under the breast, under the belly and around the flank, expressing the curvaceous fullness of the bird's form. The back should curve subtly off towards the tail and the legs should be set back slightly.

2 Mallards are colourful birds, whose plumage divides into distinct areas. Building up these coloured areas will help teach you about the application of different colours as well as understanding feather masses on birds' bodies.

3 Add in some tone to complete your mallard. The body needs to be given a sense of roundness, which can be conveyed using contoured strokes. This will give your bird a truly three-dimensional feel.

Chapter 5

DRAWING PEOPLE

How does the old saying go? 'The great thing about so-called folk.' And have you ever considered that, in relation to drawing, as people readily admit, the most diverse and challenging subject of all? For us will it in turn to draw people well – that is to say, to capture their nature and individuality – you must be sympathetic to your subjects. The French existential philosopher Jean-Paul Sartre once famously said that 'Hell is other people.' Well, hopefully you don't share that uncompromising misanthropic view of the rest of humanity, but if you have come to find off other folks as you've become older, as sometimes happens, perhaps you had better stick to drawing landscapes or animals instead!

Then again, pass up the opportunity to create portraits of your nearest and dearest and you will be missing one of the most rewarding areas of drawing. Capturing the light in a child's eyes, the texture and volume of a young woman's hair or even the wrinkled brow of your other half will provide hours of drawing delight. So, stop grumbling,

Chapter 5

DRAWING PEOPLE

How does the old saying go? Oh yes, 'there's nowt so queer as folk'. And never was a truer word spoken in relation to drawing, as people represent possibly the most diverse and challenging subject you will ever find! In order to draw people well – that is, truly to capture their nature and individuality – you must be sympathetic to your subjects. The French existential philosopher Jean-Paul Sartre once famously said that 'hell is other people'. Well, hopefully you don't share that intensely misanthropic view of the rest of humanity, but if you have rather gone off other folks as you've become older, as sometimes happens, perhaps you had better stick to drawing landscapes or animals instead!

Then again, pass up the opportunity to create portraits of your nearest and dearest and you will be missing one of the most rewarding areas of drawing. Capturing the light in a child's eyes, the texture and bounce of a young woman's hair or even the wrinkled brow of your other half will provide hours of drawing delight. So, stop grumbling,

get some friends or relatives round, and let's start drawing some people!

Head Outlines and Profiles

We see people wherever we go and from birth have an incredibly perceptive and efficient capacity for facial recognition. You might think then, that drawing people's heads and faces would be easy; however, think again, because guess what – it's actually pretty difficult!

Frontal outlines

As always, start by drawing an accurate outline of your subject's head. We're going to begin by doing this head-on, while attempting to capture the correct shape of a human skull and the basic facial features. Observe the simple illustrations below to get you started. Practise copying these for a little while on a few odd bits of paper.

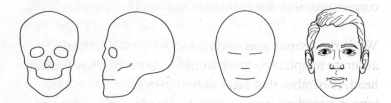

When drawing a head from the front, think of it as being shaped like an egg, with the broader end at the top. Halfway down this egg shape is where the eyes should be positioned. Then, halfway between the eyes and the bottom of the jaw line, the underside of the nose should be positioned. Halfway between the nose and the chin

is where the mouth line should be positioned. These might sound like sweeping generalizations, but whatever the size of the head or the shape of the face, the relative proportions and positions of the facial features are fairly constant from one person to another. The relationships between these can be illustrated by dividing up the frontal view of the face using a grid. Grids are discussed in a variety of different places elsewhere in this book (see pages 42–46), so we will not repeat that information here. However, rest assured that a grid will work for drawing a human face or figure as well as it works with anything else!

Head profiles

The basic guide outlined above applies equally to a head in profile, but the shape viewed from the side looks very different because the skull extends further back. Seen in profile, the structure of a face is still very much like an egg, but one with a flattened side. You can use lightly drawn dotted lines on your profile outlines to help ascertain the correct positions for eyes, nose and mouth.

While the proportions outlined above provide a fairly accurate template to work from for just about any human head, remember that faces vary enormously. Some have long, protruding jaws, or high foreheads, or very narrow cheeks and so on. This is where observation plays such a huge part once again; remember the mantra at the heart of this book – look, look and look again!

Drawing faces turned away from you at various angles requires drawing facial features in perspective. Continuous curves in perspective are difficult to draw, so it helps to

make studies of the head using the block method. This is similar to using a grid. Imagine the head as a box – the cheeks as two of the sides and the underside of the chin, the face, the back and top of the head as the other four. Alternatively, you could see the face divided into a series of planes (see the illustration below).

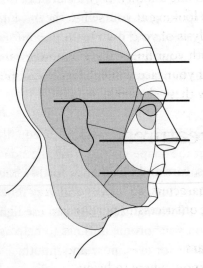

The parallel planes and horizontal lines of the nose, eye or mouth levels are all subject to the laws of perspective. This means that the eye closest to you will look larger but will also appear to be slightly higher than the one further away. Certain features of the entire face need to be foreshortened if they are drawn from certain angles. (For information on foreshortening as a technique, see pages 104–5.)

Drawing head shapes accurately takes a lot of practice, just like anything else in drawing. However, be confident

that your skills will improve very quickly and you will soon start to create very realistic representations of heads and faces. As ever, observation and careful thought are the keys to success. The more time you spend looking at your partner's face, or those of your friends and other family, the better you will understand how features work in relation to one another. If you can bear to, you can even spend hours looking at yourself in the mirror! Seriously, a visual analysis of your own features combined with a good feel with your fingertips around the various contours and facets of your face will enhance your understanding of how to draw these elements.

Facial Features

It's their eyes, ears and lips that define most people's looks and facial characters, so learning to draw these well is an integral part of successful portraiture.

Eyes and ears
It's hard to know where to begin when it comes to drawing eyes and ears, because they come in such a range of shapes and sizes! We can do no better than to ask you to try copying the eye close-ups illustrated on the right.

Notice the differences in eyelids in particular. They can be thick, thin, heavy, bulging or barely visible. The lower eyelid usually

shows only a rim from which fine eyelashes sprout.
The only way to perfect details like this is to practise –
constantly.

The size of the pupil (the dark circle in the middle of the
eye) varies according to the light, and the vision of the
person being drawn. When drawing eyes, remember to
leave a white spot on the pupil. This denotes reflected
light which gives life to an eye in an illustration. The iris
(the area immediately surrounding the pupil), should be
drawn with fine lines which radiate out. Dark eyes can be
represented with dense shading or blocking.

Ears are curious things at the best of times, and like eyes,
the diversity of their shapes and sizes is extraordinary.
Sketch them from a variety of angles and try adding
shading to emphasize the lobes, contours and valleys that
define this weirdest of human features.

Noses and lips

These present the same
challenges as eyes and ears,
although you will generally
not have to invest these
features with as much
character as your eyes.
Again, get in the habit of
practising lots of different
shapes and sizes of noses
and lips. See the illustrations
on the right for inspiration.

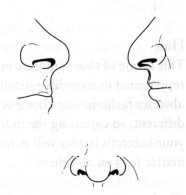

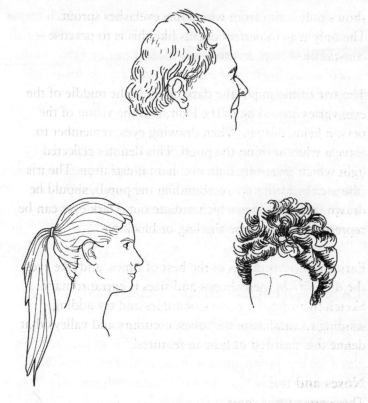

Hair

This is one of those subjects in drawing that can either be represented in incredible detail or drawn in an amorphous, abstract fashion. The choice is yours. Everybody's hair is different, so capturing the individual style and texture of your subject's barnet will in many respects be a personal matter for you and them.

The best way to get used to drawing hair is to start by practising different hairstyles.

You should also make careful decisions about which media to use when you are attempting hair. The detail of fine hair should be sketched with a fine-nibbed pen or hard pencil, whereas you might prefer to represent a dark, lustrous mop of hair using heavy shading and blocking in with a very black pen or pencil.

The important thing to remember when sketching hair is that it reflects strong light and has several degrees of tone. These range from dense black through medium grey to white. You should always try to emulate these tones as accurately as possible in your illustrations.

Body Shapes and Features

Over the years, detailed observation has led artists to create an idealized human body shape, in which each part has a set size proportionate to the rest of the body. We all know that this has very little to do with real life! Does your nearest and dearest resemble Leonardo da Vinci's 'Vitruvian Man' or Botticelli's 'Birth of Venus'? Probably not. So throw away the rulebook when you start drawing human forms and use your eyes instead.

Male and female body shapes

When you are beginning to draw people, perhaps the most important thing to remember is that men and women are generally quite different shapes. The widest part of the average man is across his shoulders – although of course this does change over the years. Once again, we are all

different, so don't take this as a rule of thumb. However, using the same basic principle, the average woman is broadest across her hips. The other thing to note is that generally her waist is far more evident than that of a man (that's if she's lucky of course!).

See the two illustrations for broad representations of the male and female body shapes.

Putting body parts together

A detailed knowledge of the anatomy is not essential
in order to draw figures well, but you should at least
understand how the main body parts – head and neck,
torso and limbs – articulate together. The neck, for
example, is not a vertical tube joining the torso and head
– it actually angles forward. Get in the habit of doing 'tin
can' illustrations like the one below to master the art of
putting body parts together.

This is a very good way to represent people simply. The great advantage of drawing in this way is that cylinders are easier to sketch in perspective especially for complex forms such as thighs. Once you have perfected putting your basic body shapes together in this way, you can modify the cylinders, turning them into truncated cones that will start to look a lot more like real limbs.

Draw figures in stages

We keep saying this elsewhere in this book, but the trick to drawing people successfully is to build up your illustration gradually, drawing your figure in stages. Try using the tin-can approach described above to draw some figures in a variety of poses. You could try someone sitting on a chair, squatting on the floor or leaning up against the wall. Get used to drawing your cylinders in the correct proportions to one another and in the different perspectives required to convey the various poses.

If you find it difficult to get to grips with the tin-can approach, start with matchstick men and women instead. Once you are happy with the basic shapes and proportions that you create, then try to flesh them out by building the matchstick figures into cylinder shapes as described above. Only then should you consider beginning to add features and details.

Hands and feet

Most novice artists tend to draw hands and feet far too small, for some reason. This is actually a remarkably common fault among experienced and professional artists, as well. Even the incomparable Michelangelo got the size

and scale of some of his hands and feet wrong in various portraits and sculptures. Hard to believe, but true ... Even the very best artists are only human!

One tip to help you avoid making this common mistake is to remember that a hand, from the base of the palm to the fingertips, is as long as a face. Hold your hand to your own face to see what we mean. A foot is even bigger – it measures slightly more than the length of the entire head. Take our word for it, though; don't try holding your foot up to your head ...!

When drawing hands and feet, try to *suggest* the shape and form of these features rather than concentrating on getting down every last detail. Use the following illustrations for guidance.

Remember that hands in particular can be very useful for suggesting emotion or mood in a portrait. This is because they can convey so many different sentiments. For example, a clenched fist portrays anger or tension, whereas hands held in front of the face with the fingertips touching can suggest contrition or contemplation.

Feet are harder to draw than hands and generally less important as constituents of portraits. In order to draw feet well, you need to understand the relationship of the joints in them and how they work. Analyze your own feet

to see just how complicated they are. It is far easier to portray feet encased in shoes or socks until you become very proficient indeed as an artist!

Posture, Expression and Texture

In order to capture people well in your illustrations, you have to learn how to convey their individual characteristics and mannerisms. A lot depends on your overall ability and your powers of observation, as we have seen so many times in this little book. Not to mention practice, for the umpteenth time! Beyond these indefinable elements, the best way to convey your subject's unique nature is by concentrating on their posture and expressions, largely through the medium of texture.

Posture

This is an incredibly powerful tool for conveying feeling in illustrations. In your mind's eye picture the world-famous sculpture by Auguste Rodin entitled 'The Thinker'. We are sure you know it, but if not, it depicts a naked man sitting with his elbow resting on his knee and his chin upon the back of his hand. It is this profoundly distinctive posture that conveys such a powerful message of thought and contemplation. You can bring the same power to your illustrations by drawing your subjects in lots of different positions. Try drawing a friend with their head in their hands, looking despairing. Have a go at sketching a grandchild with one knee raised, as if they are about to leap into the air. Ask a relative to lean forward in their chair, adopting an enquiring and challenging posture.

Expression

Combined with posture, expression can create remarkable effects in your illustrations and portraits. Stand in front of a mirror and practise a few of your own expressions. Try to look sad, happy, mad, bad and indifferent. Screw up your features and gurn at yourself for a few minutes. You might not enjoy what you see, but it will certainly give your facial muscles a good workout! Seriously though, if you study how the movement and changing shape of features, such as the eyes and mouth, affect the cheeks, lines around the nose and so on, you will soon begin to realize how only tiny alterations to features can convey powerful emotions in your illustrations.

Combine these alterations to the facial features with dramatic postures and you will be well on your way to creating realistic representations of people. See the illustration overleaf for a good example of what we mean. The tired and drawn features of the young woman's face combine with her slouched posture and her head resting on her hand to convey a powerful impression of depression or resignation.

Texture

Posture, expression and general body language might be the magic keys to the kingdom of successful portraiture, but how can you get these across realistically in your illustrations? Very often the answer is to use texture.

People are made up of a variety of different textures. The hair, skin, clothes – all feature different textures. Hair may

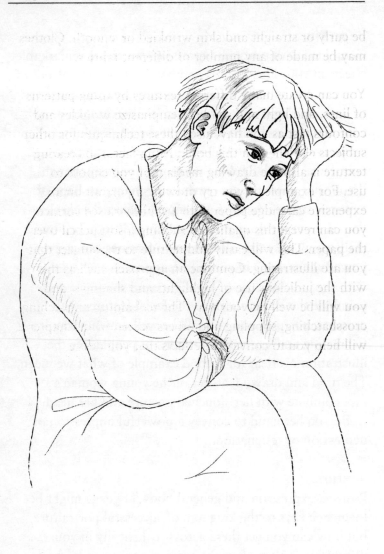

be curly or straight and skin wrinkled or smooth. Clothes may be made of any number of different fabrics.

You can create many different textures by using patterns of lines, and light and shade to emphasize wrinkles and contours just as you have used these techniques for other subjects elsewhere in this book. A big factor in creating texture is also the drawing media that you choose to use. For example, if you try drawing a portrait on an expensive cartridge paper with a slightly raised surface, you can reveal this quality by rubbing a soft pencil over the paper. This will easily add texture to the subject that you are illustrating. Combine an approach such as this with the judicious use of highlights and shadows, and you will be well on your way. The techniques of hatching, crosshatching, stippling and others described in Chapter 2 will help you to convey the effects that you desire.

Chapter 6

DRAWING STILL LIFE

You probably remember drawing still life objects from
your childhood (if that wasn't too long ago!), as still life
drawing has long been a staple of the school classroom.
No book on drawing would be complete without this
subject, which is really an entire form of art in its own
right. In fact, countless books have been devoted to
this topic alone, so in the few pages that we are able
to allocate here, we will really only scrape the surface.
So, please treat this as a gentle introduction, and if this
subject is of particular interest to you, consider taking a
class in it.

Many people start out by drawing still life, because the
skills involved in selecting suitable subjects, arranging
them in a pleasing composition and then lighting them
effectively, can teach one a great deal about drawing in
general. There can hardly ever have been a famous artist
who did not try his or her hand at still life at some point
in their career. Whenever you visit a gallery or exhibition,
you will nearly always find a corner devoted to still life,

even if the artist in question was known primarily for their landscapes or portraits.

Some people think that drawing still life is boring, presumably because of the static nature of the form and because very often the items that are traditionally selected for still life art are somewhat mundane. However, there is really no limit to what you can choose to draw as a still life composition, and it is up to you to make your drawings as interesting as possible.

Remember, as always, the key thing is to observe the items you select really closely before attempting to draw them. Analyze their lines, consider their proportions, take note of their symmetry or asymmetry – but do look very closely!

Basic Principles

So, where to start? Well, before we make some suggestions for subject matter, here are some basic rules for drawing this form.

Planning your composition

The term 'composition' refers to the organization, arrangement and combination of objects within the borders of the drawing space. The objective for any good still life drawing is to bring the eye of the viewer towards your centre of interest within an aesthetically pleasing composition. Strong composition will immediately engage your viewers. There are many rules that define how it can be achieved, but remember that your own personal preferences and natural instincts are just as important

when you are planning your drawing. However, you should always bear the following points in mind:

- Focal point – A primary centre of interest or focus in a drawing.
- Balance – A stable arrangement of different subjects within a composition.
- Contrast – The extremes of light and dark values that create shapes and patterns in your composition.
- Proportion – The amount of space that you allocate to the various components of your drawing and their sizes in relation to one another.
- Overlapping – The visual separation of drawing into foreground, middle ground and background by overlapping or layering objects.
- Negative space – the space within your drawing that is not occupied by a focal point, important subject or area of interest.
- Lines – The navigational tools that are used to guide the viewer through the different elements of any drawing.

The key thing in any composition – and this really applies to most of your drawings, not just still life – is to emphasize the focal point. This means creating a specific area where you want your viewer to focus the majority of their attention when looking at your drawing. In a still life, typically this might be a particular vase or bottle in a collection you have assembled, or an especially juicy-looking apple in a bowl of fruit. It doesn't really matter

what it is – the choice is yours – but while you want to make it the focal point, you do not want to be too literal and arbitrary in so doing. Follow these further guidelines, and you will create sensitive, subtle focal points that draw your viewer in without them necessarily understanding immediately why:

- Always place your focal point off centre. Anything you place dead centre will detract attention from the rest of the drawing, overly dominate the composition and kill the whole thing stone dead.
- Make good use of secondary focal points. Surround your main focal point with slightly less interesting objects, and they will draw the viewer's eye where you intended it to go.
- Use lines to point to your focal point. A more direct way of attracting attention to your focal point is literally to use lines leading towards it.
- Use strong definition. Define the focal point with greater shading or texture than the rest of the image and it will always stand out.

Balancing your composition

As we have seen elsewhere in this book, a good composition is a balanced composition. This applies as much in still life drawing as it does in any other area, if not more so. Good drawings are generally those in which the balance of the various subjects has been carefully planned in advance. This makes for a more aesthetically pleasing and harmonious whole. The planning involves taking the sizes, placements and values of the subjects

into account simultaneously. Without such balance, your drawings may end up being inharmonious and visually jarring. At this point, you might be thinking 'Picasso never really observed these rules!' (and neither did many others, for that matter, including Salvador Dali), but trust us, at this stage in your drawing career paying attention to a basic rule like this will reap rewards. Of course, if you want to have a go at creating a drawing that is deliberately distressing and jarring, then you could try using an unbalanced approach. Try these basic pointers to help you balance your composition successfully:

- Experiment with the shape of your drawing space. It doesn't have to be a rectangle; you could try something more adventurous like a circle or a triangle.
- Arrange your objects asymmetrically. Break up the pattern of your drawing by placing taller objects off to one side. Think how some classic city skylines look all the better for the fact that their tall buildings are placed randomly and not all together in one symmetrical unit.
- Place odd numbers of objects into a grouping. Rather like the point about asymmetry above, odd numbers of subjects arranged on opposite sides of a composition look better than even, static groupings.
- Balance dark and light values in your composition. Just as with the objects, mix up the positioning of dark and light objects in your drawing, so that there is a good balance across the composition as a whole.
- Plan proportions in advance. Work out the sizes of the key elements in your composition in relation to one

another before you start drawing. Consider how much of your composition should be background (negative space), and use overlapping to stress the difference in proportions between the principal objects.

Lighting your still life composition

One of the tricks to successful still-life drawing is understanding how lighting works in relation to your subject. Put simply, how you position the light source affects the extent to which your subject appears either flat or three-dimensional.

Try this exercise:

1 Take a vase, decanter or interestingly shaped bottle and stand it on a plain white piece of paper in front of a neutrally coloured wall.

2 Plug in a lamp just to the side of the object – an anglepoise desk lamp is ideal – so that the light shines from above and slightly to the right of the vase. This standard lighting option emphasizes the vase's shadows, highlights and three-dimensional forms.

3 Now set the lamp up so that it shines its light from the right and slightly below the vase. As mentioned above, this option creates lots of contrast between highlights and shadows, as well as illustrating the vase's three-dimensional quality.

4 Now set the lamp up directly behind the vase or bottle. This creates a silhouette-effect providing a less detailed image, as you now see only the shadow side of the vase.

5 Now set the lamp up directly in front of the subject. The shadows are now cast directly behind the vase, making it appear soft and flat. This is the same effect that you often get with flash photography.

If you have a particular reason for wanting a still-life object to look flat, then try frontal or back lighting before you start drawing. However, in most cases you will want your subjects to be as three-dimensional as possible, in which case your light source should be set above or below the object in question, or coming in from the side.

CHANGING SHAPES IN CAST SHADOWS

In order to create realistic-looking still-life compositions, it is essential to understand the changing nature of shadows according to the shape of objects and the position of light sources. Experiment with shadows by finding several differently shaped objects and placing them one at a time near a strong light. Move the light source or the objects around and watch how the shadows change shape. Try putting the objects on a different surface – maybe a gathered fabric of some description – and see how the shadows change shape again. It is fairly obvious that a different shape will cast a different shadow, but it's only when you begin to understand how this can alter according to the position of the light source that you will be able to reflect this in your illustrations.

Finally, always try to draw your still-life compositions from real objects as opposed to from photographs. This is because you will always capture so much more 'life' – still or not! – by drawing from the real thing instead of by copying a two-dimensional photographic representation. This is where using a light source, or at least observing how natural light casts itself over your object, is particularly important. In the vase and lamp exercise outlined in the box above, the positioning of the lamp would cast shadows and details on and from the vase that would never be visible in the average photograph. This is particularly the case whenever the light source is positioned above, below or to the side of the subject.

Choosing Subjects

Well, you might be a little blinded by science (if not by that lamp!) by now, so let's move on to the fun side of still-life composition, which is deciding what to draw. As we said above, the choice is entirely yours. Don't feel bound by convention – still life doesn't just have to be about fruit bowls, vases and collections of bottles. Why not climb out of the armchair, pull on your coat and go for a wander in search of inspiration? It can be fun finding random items lying on the ground in the garden or park that you can take home and draw in the comfort of your own studio or dedicated space. Old bits of wood and tree stumps can be particularly evocative and interesting to sketch, as can driftwood that has been cleaned by the river or sea and then bleached by the sun. Whatever you do, just don't let the dog get hold of them!

It doesn't matter whether what you choose to draw is symmetrical or asymmetrical, traditional or contemporary. With a little thought and creative exploration, you can find an infinite supply of subjects for still-life composition. You could choose some of your own favourite objects – maybe a few pieces of jewellery or souvenirs with particular sentimental value – or try combining several totally different objects of completely different shapes and sizes to create something really out of the ordinary.

You could visit car-boot sales, flea markets or antique stores and find some old, weathered and worn objects to draw. These often have a great deal of personality, which will come through strongly in your compositions.

One way in which you can unify a still-life drawing is to choose objects that relate to one another in some way. Consider themes such as an arrangement of children's toys, kitchen utensils and food, table settings or objects that are all the same colour or of the same texture. If you want to achieve the opposite effect, then deliberately select items that have nothing to do with one another and that are of different colours and textures. Having said that, it's probably a good idea to build your confidence first with some more conventional compositions before going mad with anything too zany!

Plants and flowers

There is something unique and truly soothing about drawing plants and flowers. The whole 'back to nature' experience makes you feel as if you're combining two or

three hobbies simultaneously, not just drawing! What could be better than getting out in the countryside on a fresh spring day and sketching some woodland bluebells or a beautiful field of poppies? There you are – drawing, walking and nature, all combined in one go! Take our word for it, sketching flowers, plants and trees in the great outdoors will gladden your heart and improve your powers of observation and aesthetic appreciation immeasurably. You'll get some fresh air, too!

Observing plant structures

As we have seen throughout this book, realistic drawing comes from keen observation. Plant structures – leaves, stalks and flowers – have great volume; you will soon note how light and shade play on and inside these structures once you begin drawing. Look very closely at the plant you've chosen to draw. Are the leaves long and thin or teardrop shaped? Are the edges smooth and wavy or serrated and are the tips pointed or rounded? How do the leaf stalks grow and branch off the main stem? What are the patterns of the flowers, stems or thorns? You won't be able to draw your chosen plant accurately until you have a detailed appreciation of its form.

Photos for initial sketches

One thing to bear carefully in mind with plants and flowers is that they can look very different according to the angle that they are viewed from. For this reason, it is a good idea to take lots of photographs that you can use for tweaking your illustration later at home. Move around the plant with your camera and capture the true essence of the plant from every angle.

Another good habit to get into is to practise sketching pot plants at home. This will make it easier to understand the form of the flowers and plants that you view in the great outdoors. If you sketch cut flowers at various stages in their decline, it is easy to notice changes in form and texture. This will help with your observation of live plants in their natural habitat.

Large numbers of plants

If you plan to draw plants in large expanses – say a wildflower meadow, for example – it is best to draw those nearest in more detail and darker than those further away, which should be seen as a mass receding into the distance. Focus on the flowers in the foreground, sketching them in first, and then look at the main lines of form or shape in your subject to help you in your composition. You can then add background detail lightly, using perspective and the relative positions of objects to create a sense of volume and depth. You should add texture, shading and detail only when you are happy with your initial outline sketches.

Fun with fruit

If it is raining outside or you just don't fancy tramping round the garden or fields, you can experiment with natural objects you will find in your own home. For example, you could totter over to the fruit bowl and try drawing that!

Fruit has long been a favourite still-life subject and many famous artists have composed memorable illustrations featuring apples, oranges, bananas and many other

delicious items. If you think about it, the reasons for the popularity of fruit as a subject are pretty obvious. Fruit comes in lots of different shapes and sizes, a wonderful array of different colours and, perhaps most importantly of all, in a tremendous range of textures. You can learn a lot from drawing fruit, such is its nature and variety. The other beauty of this subject of course, is that you can eat it as you draw it! Seriously, why not try a series of sketches of an apple, orange or banana at different stages as you consume it? Doing this might change your perception of what a still-life composition should consist of, if nothing else!

Glass and crystal

If you're going to get into still-life composition, one thing you should really try is drawing a glass or crystal object. This won't be the easiest topic you take on in your early drawing career, but it will challenge your developing skills and make you think hard about lighting. This is because the shiny textures of glass and crystal need really strong highlights and dark values in order to look realistic in illustrations.

Because light casts through glass and crystal objects as well as over them, shadows fall in unusual ways compared with other subjects. Real skill is required to render the texture of the glass crystal correctly while positioning highlights and shadows so that they look realistic. It's all a case of mixing light and dark values in the right proportions on the right parts of your subject. This is something that is hard to convey in words on the page – it's best if you just sit down and have a go at

drawing something made of glass or crystal and then you will see what we mean!

Drawing Symmetrical Objects

The most difficult skill to acquire in still-life composition is the accurate depiction of symmetrical objects. However, don't let this statement put you off! You will get a great deal of satisfaction and pleasure from learning how to draw symmetrical shapes accurately and in so doing will gain a greater appreciation of how light and shadows work in illustrations.

Try the following exercise, for which you will need a sheet of tracing paper in addition to your regular drawing materials.

1 Find a symmetrical vase or any other household object whose symmetry is obvious to you. Draw a rough sketch of the outline on a plain sheet of paper.

2 Using a ruler and pencil, locate and mark a vertical line down the centre of the vase.

3 Select one side of the vase (see illustration on page 142) and gently rub out your sketch lines so that they are barely visible.

4 Now carefully refine this side of your drawing with neat, precise lines.

5 Rub out the rough sketch on the other side of the drawing.

6 Use a ruler to draw a horizontal line across the vase perpendicular to the vertical line, about two-thirds of the way up the illustration, see overleaf.

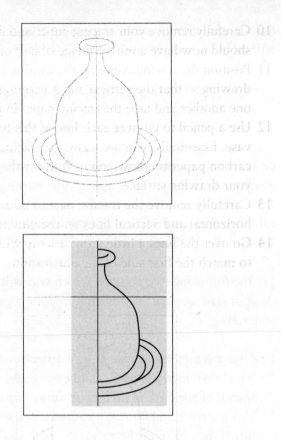

7 Carefully tape tracing paper over the refined side of
 your drawing. Don't stick the tape to the drawing itself
 – you might damage it.
8 Using a ruler and a 2B or 4B pencil, trace the
 intersecting vertical and horizontal lines.
9 Now trace all the curved lines of the vase with dark
 lines.

10 Carefully remove your tracing paper and flip it over. You should now have a mirror image of half of the vase.

11 Position the tracing paper on the missing half of your drawing so that the vertical and horizontal lines overlap one another and tape the tracing paper in place.

12 Use a pencil to go over each line of this half of the vase. Essentially, you are using the tracing paper as a carbon paper to allow you to transfer the image onto your drawing surface.

13 Carefully remove the tracing paper and rub out the horizontal and vertical lines on the illustration.

14 Go over the lines a little more heavily with the pencil to match the first side of the illustration.

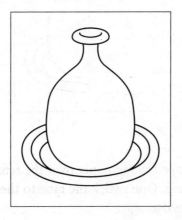

DRAWING CARTOONS

What defines a cartoon? Well, need it make us laugh... long ago as the Middle Ages, and each meant a preparatory drawing for a painting, stained glass window or tapestry. These days, it is a drawing that... and... or humour. You probably have in your mind an image; it's a newspaper cartoon from... like... Andy Capp, or Charles M. Schulz's Snoopy and Peanuts. Or perhaps it's something more contemporary, like a hugely popular and ubiquitous Simpsons...

But when does a drawing cease being a drawing and become a cartoon? There is quite a fine line here, if we think about it (just like in the drawings themselves). Consider, for example, the lovely sketches by E.H. Shepard that illustrated the classic children's tales of Winnie the Pooh by A.A. Milne. Aimed at children, and upsetting in the first half of the 20th century, were these gentle, mildly humorous images that perfectly captured the bucolic themes of Milne's stories. However, move forward a number of decades and think about Walt Disney's own

Chapter 7

DRAWING CARTOONS

What defines a cartoon? Well, the term originated as long ago as the Middle Ages, and first described a preparatory drawing for a painting, stained-glass window or tapestry. These days, it is a drawing intended for satire, caricature or humour. You probably have a favourite cartoon. Maybe it's a newspaper classic from the past, such as Reg Smythe's *Andy Capp*, or Charles M. Schulz's world-famous *Peanuts*. Or perhaps it's something more contemporary, like the hugely popular and ubiquitous *Simpsons*?

But when does a drawing cease being a drawing and become a cartoon? There is quite a fine line here, if you think about it (just like in the drawings themselves). Consider, for example, the lovely sketches by E.H. Shepard that illustrated the classic children's tales of *Winnie the Pooh* by A.A. Milne. Aimed at children, and drawn in the first half of the 20th century, these were gentle, mildly humorous images that perfectly matched the cheerful bucolic themes of Milne's stories. However, fast-forward a number of decades and think what Walt Disney Pictures

managed to do with these illustrations in their cartoon adaptations of the *Winnie the Pooh* stories for Hollywood. Pooh became a chubbier, older, almost avuncular caricature of himself (ably assisted by the voice of what sounded like some old codger from the Midwest of the USA); Rabbit, Piglet and Eeyore were all fairly grotesquely embellished in the interests of "comedy"; whereas the charming and totally original character of Tigger ended up resembling a mentally retarded, soft-bottomed toy with a chronic addiction to steroids....

You can probably tell by now that the author of this tome is not a particular fan of the Disney *Winnie the Pooh* characters (in fact, they completely spoilt this writer's childhood memories of those lovely stories), but the gentle rant above serves to illustrate the point that drawing cartoons generally involves the exaggeration of physical and facial characteristics, movements and actions. An understanding of this key factor is the most important starting point as you embark on your career as a budding cartoonist.

Children are the Best Cartoonists

Most small children are natural cartoonists. It's probably because they are so uninhibited – they draw with such bold, confident lines. You could learn a lot from watching a child at work with a pencil and piece of paper. Try to emulate the unselfconscious, joyous freedom of expression with which most children draw and you will probably find that your own skills develop in leaps and bounds.

When kids draw human beings and animals, they nearly always depict them as being happy, with great smiling faces, upright, buoyant stances and a general sense of bold, confident movement. These are all intrinsic elements of many successful cartoons, which begins to explain the statement above that children are natural cartoonists.

Detail and interpretation

If you look at most children's drawings, they often include an incredible amount of detail. This isn't always obvious at first, because the lines that most children draw tend to be primitive and basic, but the details and embellishments that kids invariably add to their characters are a reflection of their superior observational skills. For, once again, whatever the type of drawing under discussion, it is the ability to *look closely* at the subject that is the key.

While there is very often a great deal of detail in children's drawings, at the same time no two children's drawings are ever exactly alike. They are full of individual interpretation, which sets them apart. Again, this is because children are uninhibited and unselfconscious when they draw. Unlike you, they almost certainly won't be thinking about the audience for their illustrations and won't care whether anyone thinks they are funny or not. When children draw, they live in the moment and enjoy the simple pleasure of what they are doing. Their confidence comes naturally from within and suffuses the lines that they set down on the page. Liberate your own mind and approach in this way, and you will draw great cartoons!

Relive your childhood

If you have faith in what you have read earlier in this chapter, to get you in the right mood for drawing cartoons, why not try being a little childlike yourself?Nobody is suggesting anything as drastic as regression therapy, but why not try to remember how you drew as a child, and have a think about some of your old teachers or other adults who featured in your childhood past? Now, take up a pen or pencil and a piece of paper and have a quick stab at recreating their features, in the most basic and simple way.

If you have young grandchildren, ask them to sit down beside you and draw some characters with you at the same time. Copy some of their devices, lines and expressions. See if you can come up with something equally childlike. Kids see the world differently, which is what you need to do in order to draw successful cartoons. For example, presumably because they are small and often have to look up a long way at them, many children tend to draw adults with enormous feet and tiny heads. Sometimes their bodies even taper upwards as well. Clearly perspective is a problem for artists of any age! Other children might use squares to depict adult bodies or draw on wings instead of arms on their figures. Have a go at drawing in that way yourself.

Above all, when attempting cartoons, think happy and try to capture the sheer joy and enthusiasm that children bring to their drawings. There can be no better advice for creating an illustration that will hopefully make people laugh and feel cheerful.

Funny Faces

You might find it hard to believe – especially if eyesight is not as good as it used to be – but you are an expert at analyzing the faces of your family and friends. You have been all your life, as it happens. Human beings have exceptionally good powers of facial recognition and perception; it's part of what makes you a human. This means that by simply looking at familiar faces you can often tell exactly how they are feeling. Similarly, when you meet a stranger the key component of your first impression of them is often a facial expression. Instinctively you search people's faces for clues about who they are and how they may interact with you.

The next time you're with a group of people, analyze their faces and watch how their muscles create their various different expressions. Try not to stare too hard – you don't want to upset anyone or make them think that you have finally gone *completely* doolally! – but have a close look and then try translating what you see into drawings. In the process, make the drawings as humorous and cartoon-like as possible, while recreating the expressions you noted. Have a look at the box on the following pages, featuring a range of facial expressions and descriptions of what characterizes them. Hopefully this will help you create some really good cartoon faces!

FACIAL EXPRESSIONS

Frightened – The eyes are very wide open; the eyebrows are raised and curve upwards in the middle; and the mouth is a little open.

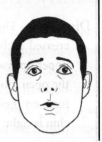

Angry – The eyes are open wide; the brow is lowered and covers part of the upper eyelids; the eyebrows are lowered in the middle; the mouth is closed but stretches taut, with the lower ends holding downwards; the chin is tight and bulges upwards.

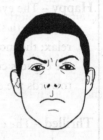

Sad – The upper eyelids fold upwards towards the middle; the eyebrows bend upwards towards the middle, forming vertical and horizontal creases on the forehead; the corners of the mouth curve downwards.

Disgusted – The eyes are partially closed; the eyebrows are lowered in the middle; vertical folds form on the brow; horizontal creases appear between the eyes; one side of the upper lip raises in a sneer; the lower lip and chin push slightly upwards.

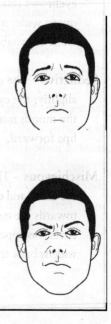

Dismayed – The eyes are closed and creased at the outer corners; the upper lip widens downwards on the open mouth; vertical creases form on the lowered brow; the chin is tight.

Happy – The eyelids lower; the upper teeth show; the eyebrows relax; the mouth widens, with the corners curving up and back towards the ears.

Thrilled – The eyes shut; the eyebrows relax; the mouth opens wide; most of the upper teeth are visible.

Seductive – The upper eyelids close slightly; the eyebrows raise; the mouth muscles push the lips forward.

Mischievous – The eyes narrow; the brow and eyebrows lower towards the middle, and partially cover the upper eyelids; the mouth widens back towards the ears.

The key thing is to exaggerate every facial expression that you draw. A successful cartoonist stresses emotions via exaggerated facial features, so that a reader instantly knows what the cartoon character is feeling.

Success through experimentation

Draw some oval shapes on a piece of paper to use as cartoon heads. Now, play about with a pencil as if you were a child! Draw different facial features onto each of the ovals. Use upward-curving lines to denote happiness (particularly in the mouth and eyebrows), and downward-curving lines to show discontent or unhappiness. Try some big noses, little noses, clenched teeth, grinning teeth – anything you like, really. Next, add some hair. Comedy hair that sticks up outrageously, a few wispy strands, a great black blob sitting on top of the head! The choice is yours. Then, do the same thing, but this time drawing heads and faces in profile. Experiment with the expressions described in detail in the box above and you should soon get the hang of the most important aspect of all cartoons – the way the characters' faces look.

If you find it difficult to bring all this advice to bear at once, pick up the newspaper and find a favourite cartoon. Study it for a while, trying to understand what makes the characters unique and precisely what defines them. Now, have a go at copying that cartoon. Don't be put off if the results are not pleasing at first – they will get better with practice!

Funny Figures

Drawing cartoon people
is actually a lot more
simple than you might
think. Just like any other
drawing – and as we
have seen throughout
this book – cartoon
characters are made up
of a simple arrangement
of shapes. To see what
we mean, take a look
at the cartoon wooden
figure drawing opposite.
Do you see how each
part of the figure is
actually just a shape?

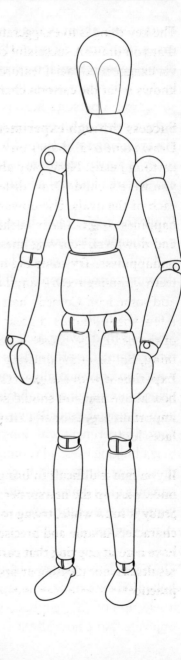

If you think about it, drawing cartoon people can be easier than drawing other things. That's because even though people may look very different from one another in many different ways, they all still have the same basic structure. A person's head is pretty much always going to be a circle or an oval. A character's arms and legs are always going to be shaped like long rectangles. And the other beauty of cartoons is that this structure can be exaggerated and embellished just as much as you wish.

While the size of each shape that makes up each body part may change, the arrangement of the fundamental shapes will not. Once you get the hang of this basic arrangement, drawing cartoon people will become much easier.

Keep it simple

Start out by drawing stick people. Seriously! Get used to arranging the proportions of the body parts so that what you draw actually resembles a human being. Then, using your imagination, begin adding bits and pieces to your character, embellishing the basic structure of the figure. Experiment with long or fuzzy hair; add some huge, bulging eyes, a fat tummy and an enormous bottom; draw huge hands, with fingers that look like a bunch of bananas. You could also include some giant feet, or boat-like shoes – these are the stock-in-trade of the cartoonist's visual devices.

Once you have created a handful of stick figures with bolted-on extremities and embellishments, try drawing a selection of different body shapes like those shown opposite. Note how all the shapes are derived from simple

circles, oblongs and rectangles. Draw the bodies without heads, initially. As the heads and faces of cartoon characters are nearly always their most expressive and defining elements, as we have seen above, add these later on to any body shapes that you are particularly pleased with.

Body language

Just as you learned how to draw cartoon faces by analyzing the facial expressions of your nearest and dearest, do the same with their body language. Become a people watcher! Notice how people sit, stand, walk, talk and move their hands and feet around. Watch how they incline their head when they are talking to you or how they throw it back when they are laughing. Then, get into the habit of jotting down a quick sketch or even a stick figure based on what you see. Try not to let the model see what you are doing, though – they might be inclined to think you are a stalker!

Now, try investing some of the characters you drew earlier with the body language that you have observed. You can do this both to your stick characters and the shapelier creations you drew afterwards. As always with cartoons, the important thing is to exaggerate every movement, action and position. The beauty of this branch of the medium is that you have complete license to create whatever you see fit!

Feature Creatures

All the same principles that apply to drawing human cartoon characters really also apply to cartoon birds and animals. When you create your cartoon feature creatures, you should be limited only by your own imagination. Be as creative and as original as you possibly can. You might not sketch the next Mickey Mouse or Bugs Bunny, but who's to say that Walt Disney and Warner Brothers are the only ones who can create great animal characters!

Careful construction

The key thing to remember when drawing cartoon animals – apart from exaggerating absolutely every feature and action – is to construct your characters carefully, using a set of basic shapes. At the outset of your drawing, don't get hung up with a detail like a big beak for a bird, long whiskers for a cat or a huge pair of ears for a rabbit; instead, begin by roughing out the basic shape of the creature you have decided to draw with a series of ovals, rectangles, triangles or circles, until something satisfying and ideally amusing begins to emerge on the paper before you.

When attempting cartoons, many amateur artists make the basic mistake of not proceeding in this way. This is because they put too much emphasis on the importance of exaggerating individual features and characteristics *before* they have actually got the character 'down' in the first place. However, the simple rule of defining the outline and basic shape of your animal character applies as much when drawing cartoons as it does to any other area of drawing. It is absolutely fundamental to creating a successful cartoon. Without this approach, you will lose control of the proportions of your figures, and while they might look funny and possibly outrageous with their exaggerated features, they will probably also look completely ridiculous. So, remember: keep it simple and construct your characters carefully. Always add the details and exaggerated features later on.

Instant inspiration

So, which animals are you going to draw? Well, this is where Rover or Tiddles might come in useful once again! Yes, the family dog or cat is a seemingly inexhaustible resource for the amateur artist.

Take a close look at your sleeping cat (it's bound to be sleeping …!). Does he or she have a funny nose that could be easily exaggerated in a cartoon? What about those whiskers? You could do something with those, couldn't you? How about giving him a really erect tail? That would immediately make him look upright, jaunty and probably a little comical. Of course, the same observations could apply to Rover the dog, too – we wouldn't want him to feel left out.

Cartoonists often exaggerate the size of animals when they draw them, as this is an easy way to convey visual humour. Pigs are always huge, with great fat tummies and ludicrous facial expressions. Giraffes always tower over everything else. Horses tend to be of the pantomime variety, looking as if it is actually two men in a suit rather than a real animal. Elephants are often unfeasibly massive and usually about to sit on someone. If you are bored with drawing your cat or dog (and if you have been following the advice in this book, you have probably done this about 1,000 times by now!), then copy some photographs of some really big animals and turn them into your favourite feature creatures.

Drawing Caricatures

A caricature is a cartoon of a person or animal that exaggerates the distinctive and unique facial features of that particular individual. That is to say, it is an over-the-top impression of a real person – a sort of cartoon snapshot, just as if your digital camera had a setting called 'caricature'. (Now that would be fun, wouldn't it?) You can find lots of examples of caricature in just about any newspaper, any day of the week. Political cartoonists glory in mocking the less-attractive characteristics of statesmen, celebrities and other famous people in the news. A good contemporary example is Gerald Scarfe (who draws for *The Sunday Times*, among others), but there have been newspaper caricaturists around for centuries. One of the most famous from the past was the 18th-century artist, William Hogarth. He positively revelled in depicting royalty and other famous people of the day as gargantuan gluttons, oleaginous, obsequious creeps and seamy harlots. As you might imagine, his work was remarkably popular!

Choosing your subject

The easiest way to begin drawing caricatures is to start with someone you know very well. So think of your spouse, your friends, or your family: would any of those make a good caricature? Who knows. But they are handy, probably nearby – and you know those features better than anybody else's ... Otherwise, there is always the dog or cat (again!).

Getting started

Take up your pad and pencil and follow these easy steps to try your hand at drawing a caricature:

1 Carefully observe the overall shape of the head and face, and exaggerate it as you draw it.
2 Lightly sketch the location of each individual feature. In a realistic portrait, there are five crucial spaces on a face that must be drawn accurately in proportion to one another in order to achieve a recognizable likeness of the subject. When creating a caricature, these same five spaces should be exaggerated, but they will still serve as crucial guidelines for rendering an image that looks like the person you're drawing. The five spaces are as follows:
 • The vertical distance from the hairline down to the eyebrows.
 • The horizontal distance between the eyes, from one inside corner to the other.
 • The width of the face, from the outside edge of one cheekbone to the outside edge of the other.
 • The vertical distance from the bottom of the nose to the top of the upper lip. This is the most important distance on the face.
 • The length from the edge of the bottom lip to the bottom of the chin.
3 Look continuously at your model, searching for unique or unusual aspects of their features that you can exaggerate in your drawing. (Remember, though, you don't want to be beaten to death with the tea tray, so don't overdo it!)

4 When drawing a caricature, exaggerate prominent features. If your subject's eyes are far apart, draw them even further apart. If he or she has big ears or a big chin or nose, draw them even bigger! If his or her eyebrows are heavy, thick and dark, draw them heavier, thicker and darker! If their hair is thin, make it even thinner in your caricature.

5 Continue tweaking and adjusting details of your caricature until you are happy with the overall outcome.

Now, show the drawing to your subject, and duck as they hurl the mantelpiece carriage clock at you!

Chapter 8

DRAWING MEMORY LANE

One of the great things about drawing as a hobby is that by its very nature it is so personal. You draw only what you *want* to draw, you develop your own distinctive style (or at least we hope you do, after reading this book!), and above all you draw things the way *you* see them. Of all the pastimes you could adopt, drawing is probably unique in that although it has lots of rules, you can bend them as and when you see fit and as far as you like! We can tell you *how* to draw in the pages of this book until we are blue in the face, but in the end it is *you* who will be setting pen to paper and defining the subjects and style of your very own unique compositions.

An essential part of this process is the ability to learn to draw from memory. Not just long-term memory, which we will consider shortly, but the short-term memory involved in seeing and perceiving something and then quickly turning it into a sketch. Your mind might not be the finely honed tool it once was (!), but it is never too late to train it with new skills. Learning how to improve your visual

perception and memory is a particularly useful skill to acquire as a budding artist.

Capturing an Image in Your Mind

When you capture an image in your mind, you use the two following faculties:

- **Vision** – Although this word pertains primarily to your sense of sight and is most often thought of in relation to things you see with your eyes, vision also relates to memory, dreams or anything that you see in your mind's eye.
- **Perception** – This is your interpretation of what you see – whether directly with your eyes or in your memory or imagination. It relates to the manner in which you understand and then process sensory information.

Although your eyes capture what is immediately before you, just as if you 'see' something with your memory or your imagination, it is your perception that defines how you log the image in your brain. Perhaps the easiest way to explain this concept is to remind you of the old maxim that people see things differently. Never was a truer word spoken! Ask several people to describe something they have just seen at the same time and under exactly the same conditions and you will get a range of different responses. Try it sometime – gather a few of your friends or family together, ask them to look at something and then get them to describe it, one by one. We guarantee that everyone will tell you something different. The fact is that your perceived visual image of an object may not be the same as

what that object actually looks like. Your eyes might see an object accurately, but your brain records images based on your memories, experiences and perceptions. And everybody's brain is different! As somebody once said, consequently memories can be very unreliable ...

Not to worry, though. Your memory might be fragile and easily distorted by your current visual perceptions, but you can still draw your interpretation of something from it. The other thing you can do is to use a series of visual prompts in the form of photographs, paintings or other media to remind you of what your roughly remembered subject looks like in 'real life'. Depending on what you are trying to remember and draw, the more knowledgeable about various subjects you become, the better you will get at accurately remembering what you see.

Storing images away

There are various tricks we can use to help fix images in our mind and hold them there for a period of time. Have you ever seen one of those memory magicians who can faultlessly recall the order of an entire deck of playing cards? That's 52 separate memories, one after the other, recalled in a flash! Incredible! But apparently these memory masters use a series of shapes, numbers, colours and other visual prompts that to them uniquely signify each individual playing card. Well, you can sort of learn to do the same thing – if to a somewhat more limited degree ...

Put simply, you can store information in your mind in different formats. You might choose to do this verbally, in which case a concise verbal description will often

provide you with an accurate and lasting visual image.
Alternatively, you might simply see the object in your
mind's eye, remembering it clearly visually. Everybody is
different. Do whatever you feel most comfortable with.
You might find that the combination of the visual and
verbal memory methods works best for you, or perhaps
your brain works in such a manner that you have a totally
different way of remembering things!

Drawing From a Visual Memory

When it comes to translating visual memories onto paper,
it pays to remember that the sooner you do this the more
accurate the representation of what you saw will be.
So, carry your sketch pad and pen or pencil with you
at all times and *draw, draw, draw* – before you forget
everything! Of course, it's not always convenient and
maybe quite embarrassing to do this in certain situations,
so it is a good idea to work on your visual memory skills
so that you can draw on them later when necessary (if
you'll pardon the pun ...).

One good way to improve your visual memory is to select
an object, draw it, put it away and think about it and
then revisit the sketch again later on. Take the object back
out of its place of safekeeping, and compare it with your
initial sketch. Attempt another drawing of the object, or
add some more details to your first drawing. Then, put
the object away again for a few hours and revisit both it
and the drawing a little bit later on. Keep doing this for
a couple of days and (hopefully!) you will be amazed by
how much your powers of recollection improve.

Another way to enhance your powers of visual memory is to 'log' what you see in your mind and then immediately research similar images on the Internet or in books and magazines. For example, if you see a dog on the street that you like but you are not sure of its breed, you could try going on to an Internet search engine, selecting the 'Images' option and then entering a range of appropriate doggy characteristics until you succeed in getting a picture of the canine you saw earlier. Of course, this will work better with a very distinctive-looking dog, say with bright red curly hair from top-to-toe, rather than with some generic black-and-white mutt, but we're sure you get the picture. Once you succeed in getting the images you want, print them off from as many different angles as possible and start drawing. It's cheating a bit, but your visual memory was still responsible for the original idea!

Old visual memories

Of course, memory is not just short-term – it can be a lot longer than that ... And you know this better than most! Mentally, the nights might be drawing in, so to speak, but the chances are that you have a positively golden hoard of unique and special memories stashed away in the recesses of your highly experienced mind. If this is the case, perhaps some of them are positively bursting out, just waiting to be drawn.

And why not? As we said earlier, there is no reason why visual memories have to be absolutely accurate and watertight. Interpretation is all in art, and of course drawing is no exception. So, why not revisit the halcyon days of your youth and dredge up some characters

and experiences from your past? You can have a lot of fun experimenting with your mental images and, who knows, they might even prove fairly accurate. You could always compare your drawings from memory with old photographs later on ...

Drawing from a Verbal Memory

As you become increasingly skilful as an artist, you will probably be more confident about interpreting subjects in different ways and attempting different styles of drawing. One thing that you might like to try is drawing from a verbal memory. This could be one of your own – although it probably need not be, as most of us store our memories visually in our heads – but how much more fun might it be to ask your other half or an old friend for one of theirs?

Just think of the pleasure you could give by recreating one of your partner's or friend's favourite memories of the past in a really good drawing. You could work with the provider of the memory, getting them to comment regularly as you create the illustration, or alternatively you could write down their special recollection, draw your composition without them knowing and then present it to them as a surprise gift.

This technique is actually not nearly as difficult as it might at first sound. The key thing is to gather as much detailed information as possible about the person, object or event in question before you begin drawing.

If you think about it, this very technique is used every day of the week by the police force and security services. You have probably seen a composite drawing of a criminal suspect, rendered by a sketch artist on a real-life television show such as *Crimewatch,* on a TV drama or in a Hollywood film. The chances are that the artist will be fairly accomplished, but there is no particular special talent involved in creating such a drawing. If anything, the skill lies with the person providing the memories of the individual in question.

So, if you decide to give someone a treat by recreating one of their special memories, don't ask them to recall their golden moment when they have just woken up or sunk quarter of a bottle of single malt! You might not get a very accurate account!

Drawing from Old Photographs

If, after reading all the above, you are still not convinced and think your memory is simply too patchy to rely upon, why not try copying some old photographs? Whether you choose to create your compositions exclusively from real life, from your imagination, from photographs or any other medium, is entirely up to you. Nobody can tell you that it is pointless recreating a photograph. Once again, the beauty of drawing is that you are the boss; you decide what you want to draw, how and when. Drawing from photographs probably cannot replace the benefits of drawing real things in real life, but there is nothing intrinsically wrong with adopting this approach.

After all, you might decide to recreate a photograph for posterity because the subject of the image is no longer alive. A cherished pet (or family member), could be reborn through one of your personalized compositions, in a way that a very old photograph simply might not do justice.

Similarly, perhaps the photograph is in black and white? You might choose to draw the subject in glorious Technicolor, which is an unimpeachable reason to create a new version of the image.

Finally, the photograph might be very old and bleached out, or simply very dog-eared. If it's a valuable family heirloom or holds even a little sentimental value, you might be doing the owner a favour by offering to recreate the image with your new-found skills.

Drawing your Friends and Relatives

When you are starting out in drawing, it pays to have a sympathetic and appreciative audience. Hark back to the very beginning of this book and you will remember the discussion about the confidence required to draw well. Many people find it difficult to draw in an uninhibited and carefree manner precisely because they lack confidence. Drawing can only become a pastime that you truly enjoy if you can relax and grow in confidence with practice.

If these words apply to you – if you lack confidence and feel that your drawing skills are simply not improving

– then turn to the people who will be most helpful and supportive. Draw your friends and relatives.

Familiar faces

One of the advantages of choosing friends and relatives as subjects for your compositions is that you know their faces so well. Consequently, you will probably find it easier to master their features rather than those of strangers. If you are drawing from memory – that is, the friend or relative in question is not sitting in front of you – then this will certainly be the case. Ideally, though, get your partner, close friend, child, grandchild or whoever to sit before you and then attempt a portrait. Draw in pencil so that it is easy to correct any mistakes and show your friend or relative the drawing every now and again, asking them what they think of your impression. They are bound to have a view on how well you have captured their image and might even be able to give you a few helpful tips!

Striking out

Friends and relatives obviously know you well and so probably won't mind if you experiment a little when you are drawing them. Why not have some fun with them? In Chapter 7, we discussed caricatures and how to create them. There are no better subjects for these kinds of drawings than close friends and relatives, again partly because of their familiarity and also because of their likely indulgence. But you could go further. You could draw a friend or relative with a completely different hairstyle or colouring, or depict them wearing outlandish gear or some bizarre costume. Ask them how they would

like to be drawn. Perhaps your grandson would like to be recreated as Superman, or maybe your granddaughter as Snow White? (Although these days she's probably more likely to want to be Beyoncé …!). Personalized cartoons are another enjoyable option. As always, the choice is yours. Exploit the comfort and relaxed nature of your relationship with your friends and relatives and have some fun!

Portraits as presents

Drawing offers unique opportunities to create special and personalized gifts. What better present could you give someone than a framed portrait of them, created by your own fair hand? If you wanted to give the present as a surprise, then draw the subject from memory or take lots of photographs of them at some point ahead of a special event like a birthday or anniversary. Then you will have plenty of up-to-date images to copy so that you can create a really contemporary portrait of your subject.

If the person for whom you want to create a special portrait has any particular standout features, emphasize these as strongly as possible in your drawing. If they are known for their bright, vibrant eyes, make the eyes the focal point of your portrait. If their hair is particularly thick and lustrous, reflect that in your drawing. If they are known for wearing a particular item of apparel – maybe a baseball cap or a checked waistcoat – then draw them in that. The more you can personalize your portrait and make it really special, the more gratefully your thoughtful gift will be received.

Drawing Personalized Greetings Cards

As your drawing skills develop, hopefully you will have the confidence to branch out into lots of different areas of creativity. If you are in the fortunate position of being retired and having quite a lot of time on your hands, one thing you could consider doing is creating greetings cards by hand, using special personalized designs. These would probably delight your friends and family, as there is nothing better than receiving a handmade card with a special, entirely personal message, as opposed to the mass-produced cards adorned with lame jokes that everybody else seems to send these days!

Of course, if you become really competent at drawing greetings cards, you could always approach one of the commercial card-producing firms such as Hallmark – but the gift card business is tough and highly competitive, so it's probably best to start out small and concentrate on your loved ones first! There are any number of events that you might choose to commemorate with one of your own little gems: mothers', fathers' and grandparents' days; Christmas, New Year and Easter; other religious holidays and festivals; Valentine's Day, birthdays, weddings, births, retirements, bereavements, promotions and congratulations – the list is endless!

What to use

Rough out your designs on ordinary A4 paper with a pen or pencil to get started, and then draw them onto thick drawing paper, artist's board, or good-quality cardboard.

Use your regular drawing pen for your sketches and then add lots of colour highlights to make your cards as bright and interesting as possible. As a departure from the advice given elsewhere in this book, this is one occasion when you might want to deploy some watercolour or poster paints, in addition to coloured pencils and highlighters.

In order to create greetings cards in sizes and proportions that people will recognize, dig out some old birthday or Christmas cards, measure them and then cut out your own cards to the same sizes. Alternatively, you could actually use existing cards as templates for your own designs, drawing them on paper and then sticking them on to the old gift cards themselves. These two pieces of advice might seem self-evident, but they are important, not least because you will want your cards to fit standard-sized envelopes that you can buy from your local stationers. Unless, of course you plan to make your own envelopes as well, perhaps from a variety of brightly-coloured papers?

What to draw

If you are preparing cards for a major celebration or festival like Christmas, you can copy all the well-worn themes such as snowmen, Father Christmas, robins, Christmas trees, holly and berries and you will have no trouble finding inspiration for these designs, not least from old cards you have received. However, it is much more fun and creative to come up with your own designs. Although it could be a time-consuming process, why not try to personalize designs for individual recipients of the cards – at least your closest family and friends – including visual references to things you know that they particularly like at

Christmas, or perhaps cartoons and/or caricatures of the recipients themselves? Everybody would have a good laugh at Uncle Jim portrayed as a snowman or Auntie Polly dressed up as the Christmas fairy on top of the tree! You can have real fun experimenting with such ideas and you will certainly brighten up your friends' Christmases into the bargain.

Depending on your personality and your natural bent as an artist, you might choose to draw serious, artistically themed compositions or go to the opposite extreme and create personalized cartoons. If you opt for the latter, cartoon animals are a perennial favourite for greetings cards. If you need inspiration, go to your local card shop and give the racks a quick scan. You will find endless cards depicting cartoon horses, dogs, cats, mice and reindeer – as well as lots of humorous photographs of these animals as well. Once again, you can go with the popular flow and try your hand at these, or you could be more adventurous or surreal even and try some unique, outlandish creations. How about a badger in a spaceship, a dog on a bicycle or a giraffe at a computer? Why not try a squirrel in a speedboat? Chances are your grandchildren would love designs like this, even if everyone else thinks you have gone completely batty! But then, at your stage of life, do you really care?

As always in the wonderful world of drawing, it's entirely up to you what you choose to create. Personalized greetings cards present fantastic opportunities for stretching your imagination and there is no limit to what you can choose to draw and how you choose to draw it. If

you look into your imagination and find it is blank for any reason, there are plenty of external sources of inspiration all around you. Your dog lying on the hearth rug or the birds outside the window in the garden, a beautiful bunch of flowers on the kitchen table. Pick up a magazine and find some pictures that you like – you could copy those. Switch on the television and sketch down some visual ideas from children's programmes or maybe some of the innumerable animal extravaganzas that are permanently on the box. Go online and see what you can find in the magic caves of the World Wide Web. The choice is yours, but above all have some fun!

GLOSSARY

Abstraction
The reduction or simplification of an image or object to an essential aspect (geometric or organic) of its form or content.

Aerial/atmospheric perspective
The means by which the illusion of atmospheric distance and depth is created by rendering objects in background space with less edge and value contrast. May also be accompanied by a shift from warmer to cooler hues, softer focus or lighter value.

Aerial view
Also called a bird's-eye view. Observing from a point of view at a high elevation. In perspective, when the horizon line, and thus the vanishing point(s), have been placed near or above the top of the picture frame. This applies most often to landscapes, cityscapes, etc. (Be careful not to confuse aerial view with aerial perspective.)

Axis
An imaginary straight line that indicates movement and the direction of movement.

Background
Objects or undetermined spaces surrounding the main subject of a work. The most distant zone of space in three-dimensional illusion.

Backlight
A light source positioned behind a person or object that can create a silhouette or separate the person or object from the background.

Blind contour
Line drawings produced without looking at the paper. Such drawings are done to heighten the feeling for space and form and to improve eye-hand coordination.

Cast shadow
The shadow thrown by a form onto an adjacent or nearby surface in a direction away from the light source.

Chiaroscuro
A word borrowed from Italian ('light and shade' or 'dark') referring to the modelling of volume by depicting light and shade by contrasting them boldly. This is one means of strengthening an illusion of depth on a two-dimensional surface, and was an important topic among artists of the Renaissance.

Composition
The organization and interaction of shapes, forms, lines,
patterns, light and colour.

Content
The subject and meaning of a work of art.

Continuous line drawing
A drawing in which the implement remains in uninterrupted
contact with the picture plane creating enclosed shapes.

Contour
The outline and other visible edges of a mass, figure or object.

Contour line (drawing)
A single line that represents the edge of a form or group of
forms and suggests three-dimensional quality indicating the
thickness as well as height and width of the form it describes.
Contour line drawing uses subtle overlapping planes.

Convergence
In linear perspective, parallel lines in nature appear to
converge (come together) as they recede to a point on the
eye level or horizon line. into the picture plane.

Cross-contour lines
Multiple, curving parallel lines running over the surface
of an object horizontally and/or vertically that describe
its surface qualities. Much like wire framing in three-
dimensional design.

Crosshatching
A drawing technique to shade an object using two or more networks of parallel lines in a gradual angular progression (to achieve a build up of complex value).

Diminution
In linear perspective, the phenomenon of more distant objects appearing smaller.

Drawing
Depiction of shapes and forms on a surface chiefly by means of lines. Colour and shading may be included. A major fine art technique in itself, drawing is the basis of all pictorial representation, and an early step in most art activities. Though an integral part of most painting, drawing is generally differentiated from painting by the dominance of line over mass.

Edge
The rim or border, the place where two things meet: the background (negative space) meets surface of objects (positive space), a 'tone' or 'value' meets a different tone/value.

Eye level
In linear perspective, the height at which the eyes are located in relation to the ground plane. Standing creates a high eye-level while sitting creates a lower one. In most views, the eye level will match a horizon line. The same as horizon line. All vanishing points in one and two point perspective are positioned on the eye level.

Figure
The primary or positive shape in a drawing. A shape that is noticeably separated from the background. The figure is the dominant, advancing shape in a figure/ground relationship.

Figure/ground relationship
An arrangement in which positive and negative shapes alternatively command attention. Also known as a positive/negative relationship.

Foreground
The 'nearest' space represented to the viewer. The 'front' of the visual stage. An exaggeration of perspective in which elements nearer to the viewer are shown much larger, and elements at a distance appear much reduced in size.

Foreshortening
A technique for producing the illusion of an object's extension into space by contracting its form. A way of representing a subject or an object so that it conveys the illusion of depth – so that it seems to go back into space.

Freehand drawing
Drawn by hand, without the use of any mechanical device -- without the aid of a straightedge, compass, protractor, French curves, computer equipment, etc. This is the opposite of mechanical drawing.

Gesture
A spontaneous representation of the dominant physical

and expressive stance of an object. The act of making a
sketch with relatively loose arm movements (gestures) –
with the large muscles of the arm, rather than with the small
muscles of the hand and wrist; or a drawing made this way.

Gradation
Any gradual transition from one tone to another. In
drawing, shading through gradation can be used to suggest
three-dimensional illusion.

Grid
A framework or pattern of criss-crossed or parallel lines. A
lattice. When criss-crossed, lines are usually horizontal and
vertical; and when lines are diagonal, they are usually at
right angles to each other.

Ground
The actual flat surface of a drawing, synonymous with a
drawing's opaque picture plane. In a three-dimensional illusion,
ground also refers to the area behind an object (or figure).

Halftone
After the highlight and quarter tone, the next brightest
area of illumination on a form. The halftone is located on
that part of the surface that is parallel to the rays of light.

Highlight
The brightest area of illumination on a form, which
appears on that part of the surface most perpendicular to
the light source.

Horizon line
In linear perspective, the line on which all vanishing points are positioned. More accurately described as the eye line or eye level.

Light tone
After highlight, the next light value of illumination on a form. Sometimes called indirect light.

Line
A mark with length and direction. An element of art which refers to the continuous mark made on some surface by a moving point. Types of line include: vertical, horizontal, diagonal, straight or ruled, curved, bent, angular, thin, thick or wide, interrupted (dotted, dashed, broken, etc.), blurred or fuzzy, controlled, freehand, parallel, hatching, meandering and spiraling. Often it defines a space, and may create an outline or contour, define a silhouette, create patterns or movement, and the illusion of mass or volume. It may be two-dimensional (as with pencil on paper) three-dimensional (as with wire) or implied (the edge of a shape or form).

Line gesture
A type of gesture drawing that describes interior forms, utilizing line rather than mass.

Local value
The basic tonality of an object's surface. regardless of incidental lighting effects or surface texture.

Mark
A visible trace or impression on a surface, such as a line, a dot, spot, stain, scratch, etc.

Mass
The density or weight of an object.

Mass gesture
A system of broad, gestural marks used to create density and weight in a form.

Massing
In composition: to block-in forms with the purpose of achieving an overall organization of visual weight.

Middle ground
The area in a drawing between the foreground and background.

Modelled Drawing
A method of drawing which delineates form through the use of a variety of values. A range of tones from light to dark.

Motion
The arrangement of the parts of an image to create a sense of movement by using lines, shapes, forms and textures that causes the eye to move over the work.

Negative space
The space surrounding a positive shape; sometimes referred to as a ground, empty space, field, etc.

One-point perspective
A frontal, head-on view with a central point at eye level at which all receding parallels appear to converge and vanish.

Outline
A line of uniform thickness, tone and speed, which serves as a boundary between a shape or form and its environment. It does not suggest contour, and is therefore flat, two dimensional. A silhouette.

Overlapping planes
A method of representing hierarchy of space in a drawing. Overlapping occurs when one object obscures from view part of a second object.

Perspective
Any system used to represent depth or space on a flat surface by reducing the size and placement of elements to suggest that they are further away from the viewer. (See also, one-point, two-point and three-point perspective.)

Picture frame
The physical vertical and horizontal dimensions of the paper surface.

Picture plane
The flat, two-dimensional surface on which a drawing is made.

Plane
Any flat level or surface.

Plastic
Denotes the illusion of three dimensionality or movement into the picture plane as it relates to the flat, two-dimensional nature of the picture plane itself. We refer to this as plastic space in contrast to perspective space.

Positive space
The shape of an object that serves as the subject for a drawing. The relationship between positive shape and negative space is sometimes called figure/ground, foreground/background relationship.

Proportion
A term that refers to the 'accurate' relationship of part to part in a realistic drawing. It can also refer to the expressive purposes, e.g. Distortion of proportion to consciously or unconsciously achieve a subjective intention. Proportion also relates to a sense of balance.

Reflective light
The relatively weak light that bounces off a nearby surface onto the shadowed side of a form.

Relative scale
A way to represent the spatial position of an object in three-dimensional illusionistic space so that forms drawn smaller appear further away and forms drawn larger appear closer.

Representational
A drawing that attempts to achieve a near-likeness to the objects being drawn. Drawings which strive to achieve the qualities of realism.

Rendering
A depiction or an interpretation. Also, a drawing in perspective of a proposed structure. (Rendering can be used either as a noun or as a verb.)

Scale
A ratio or proportion used in determining the dimensional relationship between a representation to that which it represents (its actual size), such as maps, building plans and models.

Shallow space
A relatively flat space, having weight and width but limited depth.

Shape
A contained, edged-in area on the two-dimensional surface. Or an area that suggests containment. A shape is always interdependent with another element (shape or space) in the composition.

Sighting
The visual measurements of objects and spaces between objects.

Silhouette
Any dark two-dimensional shape seen against a light background.

Sketch
A quick drawing that loosely captures the appearance or action of a place or situation. Sketches are often done in preparation for larger, more detailed works of art.

Space
The distance between images or points in a drawing. We contain space when defining edges of interrelated shapes.

Station Point
In linear perspective, the fixed position a person occupies in relation to the subject that is being drawn.

Surface
The actual physical structure or texture of the drawing paper containing degrees of smoothness, gloss, or roughness.

Texture
The actual or suggestive surface quality of a two-dimensional shape or three-dimensional volume. It can be created by using skillful drawing techniques, erasure, rubbing or employing specific materials such as sand.

Three-dimensional space
The actual space in the environment, and the representation of it in the form of pictorial illusion.

Three-point-perspective
A system for representing objects in space with exaggerated three dimensionality, through the use of three perpendicular sets of converging parallels.

Two-dimensional space
The flat, actual surface area of a drawing, which is the product of the length times the width of the drawing paper support.

Two-point perspective
A way of representing space on the picture plane in which physically parallel elements of the same size appear progressively reduced along converging rays to the left and right, reaching a single point on the horizon on both the left and right side.

Value
Black, white and the gradations of grey tones between them. The relative degree of light and dark.

Value pattern
The arrangement or organization of values that control compositional movement and create a unifying effect throughout a work of art.

Value relativity
The changing visual identity of values in juxtaposition, sometimes called value contrast.

Value scale
The gradual range from white through grey to black.

Visual weight
The potential of any element or area of a drawing to attract the eye.

Volume
The overall size of an object, and by extension the quantity of three-dimensional space it occupies.

INDEX

Index